Art and Architecture of China

The History and Culture of China

Mason Crest Publishers Philadelphia

Sheila Hollihan-Elliot

Art and Architecture of China

The History and Culture of China

Mason Crest Publishers Philadelphia

Sheila Hollihan-Elliot

Produced by OTTN Publishing, Stockton, New Jersey

Mason Crest Publishers
370 Reed Road
Broomall, PA 19008
www.masoncrest.com

First printing

1 3 5 7 9 8 6 4 2

Library of Congress Cataloging-in-Publication Data

Elliot, Sheila Hollihan.
 Chinese art and architecture / Sheila Hollihan-Elliot.
 p. cm. — (China)
 Includes bibliographical references and index.
 ISBN 1-59084-824-1
 1. Art, Chinese. 2. Architecture—China. I. Title. II. Series.
 N7340.E45 2004
 709'.51—dc22

 2004011651

Table of Contents

Introduction

**Dr. Jianwei Wang
University of Wisconsin–
Stevens Point**

Before his first official visit to the United States in December 2003, Chinese premier Wen Jiabao granted a lengthy interview to the *Washington Post*. In that interview, he observed: "If I can speak very honestly and in a straightforward manner, I would say the understanding of China by some Americans is not as good as the Chinese people's understanding of the United States." Needless to say, Mr. Wen is making a sweeping generalization here. From my personal experience and observation, some Americans understand China at least as well as some Chinese understand the United States. But overall there is some truth in Mr. Wen's remarks. For example, if you visited a typical high school in China, you would probably find that students there know more about the United States than their American counterparts know about China. For one thing, most Chinese teenagers start learning English in high school, while only a very small fraction of American high school students will learn Chinese.

In a sense, the knowledge gap between Americans and Chinese about each other is understandable. For the

Chinese, the United States is the most important foreign country, representing not just the most developed economy, unrivaled military might, and the most advanced science and technology, but also a very attractive political and value system, which many Chinese admire. But for Americans, China is merely one of many foreign countries. As citizens of the world's sole superpower, Americans naturally feel less compelled to learn from others. The Communist nature of the Chinese polity also gives many Americans pause. This gap of interest in and motivation to learn about the other side could be easily detected by the mere fact that every year tens of thousands of Chinese young men and women apply for a visa to study in the United States. Many of them decide to stay in this country. In comparison, many fewer Americans want to study in China, let alone live in that remote land.

Nevertheless, for better or worse, China is becoming more and more important to the United States, not just politically and economically, but also culturally. Most notably, the size of the Chinese population in the United States has increased steadily. China-made goods as well as Chinese food have become a part of most Americans' daily life. China is now the third-largest trade partner of the United States and will be a huge market for American goods and services. China is also one of the largest creditors, with about $100 billion in U.S. government securities. Internationally China could either help or hinder American foreign policy in the United Nations, on issues ranging from North Korea to non-proliferation of weapons of mass destruction. In the last century, misperception of this vast country cost the United States dearly in the Korean War and the Vietnam War. On the issue of Taiwan, China and the United States may once again embark on a collision course if both sides are not careful in handling the dispute. Simply put, the state of U.S.-China relations

may well shape the future not just for Americans and Chinese, but for the world at large as well.

The main purpose of this series, therefore, is to help high school students form an accurate, comprehensive, and balanced understanding of China, past and present, good and bad, success and failure, potential and limit, and culture and state. At least three major images will emerge from various volumes in this series.

First is the image of traditional China. China has the longest continuous civilization in the world. Thousands of years of history produced a rich and sophisticated cultural heritage that still influences today's China. While this ancient civilization is admired and appreciated by many Chinese as well as foreigners, it can also be heavy baggage that makes progress in China difficult and often very costly. This could partially explain why China, once the most advanced country in the world, fell behind during modern times. Foreign encroachment and domestic trouble often plunged this ancient nation into turmoil and war. National rejuvenation and restoration of the historical greatness is still considered the most important mission for the Chinese people today.

Second is the image of Mao's China. The establishment of the People's Republic of China in 1949 marked a new era in this war-torn land. Initially the Communist regime was quite popular and achieved significant accomplishments by bringing order and stability back to Chinese society. When Mao declared that the "Chinese people stood up" at Tiananmen Square, "the sick man of East Asia" indeed reemerged on the world stage as a united and independent power. Unfortunately, Mao soon

plunged the country into endless political campaigns that climaxed in the disastrous Cultural Revolution. China slipped further into political suppression, diplomatic isolation, economic backwardness, and cultural stagnation.

Third is the image of China under reform. Mao's era came to an abrupt end after his death in 1976. Guided by Deng Xiaoping's farsighted and courageous policy of reform and openness, China has experienced earth-shaking changes in the last quarter century. With the adoption of a market economy, China has transformed itself into a global economic powerhouse in only two decades. China has also become a full-fledged member of the international community, as exemplified by its return to the United Nations and its accession to the World Trade Organization. Although China is far from being democratic as measured by Western standards, overall it is now a more humane place to live, and the Chinese people have begun to enjoy unprecedented freedom in a wide range of social domains.

These three images of China, strikingly different, are closely related with one another. A more sophisticated and balanced perception of China needs to take into consideration all three images and the process of their evolution from one to another, thus acknowledging the great progress China has made while being fully aware that it still has a long way to go. In my daily contact with Americans, I quite often find that their views of China are based on the image of traditional China and of China under Mao—they either discount or are unaware of the dramatic changes that have taken place. Hopefully this series will allow its readers to observe the following realities about China.

First, China is not black and white, but rather—like the United States—complex and full of contradictions. For such a vast country, one or two negative stories in the media often do

not represent the whole picture. Surely the economic reforms have reduced many old problems, but they have also created many new problems. Not all of these problems, however, necessarily prove the guilt of the Communist system. Rather, they may be the result of the very reforms the government has been implementing and of the painful transition from one system to another. Those who would view China through a single lens will never fully grasp the complexity of that country.

Second, China is not static. Changes are taking place in China every day. Anyone who lived through Mao's period can attest to how big the changes have been. Every time I return to China, I discover something new. Some things have changed for the better, others for the worse. The point I want to make is that today's China is a very dynamic society. But the development in China has its own pace and logic. The momentum of changes comes largely from within rather than from without. Americans can facilitate but not dictate such changes.

Third, China is neither a paradise nor a hell. Economically China is still a developing country with a very low per capita GDP because of its huge population. As the Chinese premier put it, China may take another 100 years to catch up with the United States. China's political system remains authoritarian and can be repressive and arbitrary. Chinese people still do not have as much freedom as American people enjoy, particularly when it comes to expressing opposition to the government. So China is certainly not an ideal society, as its leaders used to believe (or at least declare). Yet

the Chinese people as a whole are much better off today than they were 20 years ago, both economically and politically. Chinese authorities were fond of telling the Chinese people that Americans lived in an abyss of misery. Now every Chinese knows that this is nonsense. It is equally ridiculous to think of the Chinese in a similar way.

Finally, China is both different from and similar to the United States. It is true that the two countries differ greatly in terms of political and social systems and cultural tradition. But it is also true that China's program of reform and openness has made these two societies much more similar. China is largely imitating the United States in many aspects. One can easily detect the convergence of the two societies in terms of popular culture, values, and lifestyle by walking on the streets of Chinese cities like Shanghai. With ever-growing economic and other functional interactions, the two countries have also become increasingly interdependent. That said, it is naïve to expect that China will become another United States. Even if China becomes a democracy one day, these two great nations may still not see eye to eye on many issues.

Understanding an ancient civilization and a gigantic country such as China is always a challenge. If this series kindles readers' interest in China and provides them with systematic information and thoughtful perspectives, thus assisting their formation of an informed and realistic image of this fascinating country, I am sure the authors of this series will feel much rewarded.

For many centuries Chinese civilization developed in relative isolation, leading to a unique culture with distinctive artistic and architectural styles. Seen here is a tower at the sprawling Ming Tombs complex, located northwest of Beijing.

1

Overview: Important Cultural Themes

The arts are shaped by, and in turn reflect, the culture of the people who develop them. Geographically isolated for thousands of years, China developed a unique civilization whose traditions, ideas, and values can be seen in its distinctive art and architecture.

What is Chinese culture like? What makes the Chinese people *Chinese*? How did China's arts and architecture evolve over millennia of cultural isolation? This book will attempt to shed light on these important questions.

The Chinese Family

Early Chinese culture began in small farming settlements along the Yellow River, where several families would cluster together for mutual aid and protection. They built mud walls around their tiny villages to keep out enemy raiders and fierce animals like tigers and bears. Protective walls around family compounds and cities continued to be built in China until recently.

From early times, individual Chinese families formed larger family groups that incorporated multiple generations of people related by blood. These big family groups, which offered greater protection than individual families alone could expect, were headed by the oldest man and were organized in a hierarchy from oldest to youngest. Within the family, each older person took care of the next younger person. Each younger person learned from and obeyed the older family member.

For even greater security, a family might join a bigger, stronger family group. In that case the weaker family took the name of the protecting family it had joined. This way, many people could be called Wu, for example, even though not every Wu was related through bloodline.

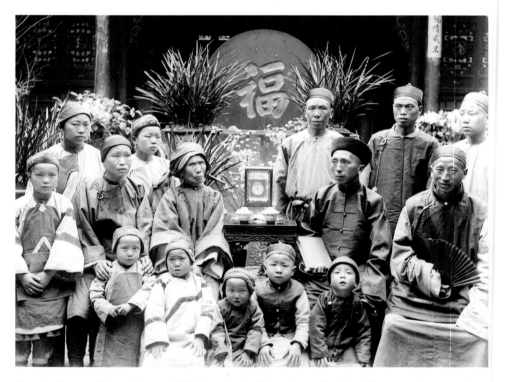

From the earliest days of Chinese civilization, the family group served as the primary focus of people's identity. Loyalty to one's extended family was among the highest values and took precedence over individuality.

FAST FACT

Chinese people traditionally called family members by their relationship in the hierarchy (eldest brother, eighth aunt, and so on) rather than by given names. This custom is still used by Chinese as the polite way to address relatives.

As a member of a family group, a person could expect help when he or she needed it. If a family member asked for help, it was given without question. When one member was attacked, this was considered an attack on the whole family because all were bound together in loyalty.

In times of war, turmoil, or rampant corruption, a family group was often a better protector than the government. What a person gave up in individuality was more than made up for in mutual aid within the family. The idea of family and extended family loyalty has lasted thousands of years. It is still an important part of Chinese culture today, even for many Chinese who live outside China. Regardless of what nation a Chinese family lives in, the head of the family, and not the country's government, often makes the law and decides the outcome of conflicts on a day-to-day basis.

But families offered more than just protection. They developed super-identities of their own, which is significant for the development of the arts in China. If a family member did great things, the honor reflected on the whole family. Conversely, a family member who failed brought shame upon the family. Thus, a culture of hard work to succeed and avoidance of failure developed in these tightly interwoven family groups. Individuality was less important

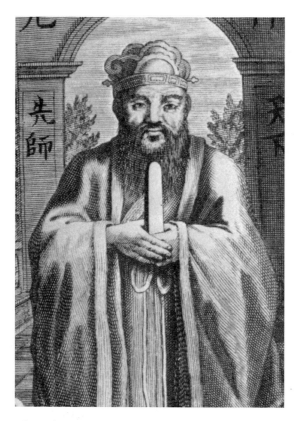

The Chinese sage Confucius (ca. 551–479 B.C.) taught that strict adherence to rules of behavior could cultivate humanity's basic goodness. He also encouraged people to study and copy the past, which he believed was better than the harsh times in which he lived.

than the duty to do one's best for the family.

Confucius vs. Tao

The sage Confucius (ca. 551–479 B.C.) codified these ideas. Born in the state of Lu (in the present-day northeastern province of Shandong), he lived in a tumultuous time, when strife and warfare were widespread. Confucius understood that people are capable of great evil, but he also believed that life could be made happier if people behaved well toward one another. To this end, he wrote many rules for proper behavior. He also encouraged people to study and copy the past, which he felt was better than the cruel times in which he lived. In the arts, Confucius's principles provide the foundation for the practice of copying the old masters. In Western cultures, copying is frowned on and at its extreme would be considered cheating or plagiarism. In China, where Confucian ideals continue to exert tremendous influence, copying is seen as a worthy artistic task, one that gives honor to past masters.

Around the same time as Confucius, another sage, from the fertile, less tumultuous southern region, is said to have espoused an opposing idea that was less rigid and more mystical. Lao-tzu (also spelled Laotze and Laozi) is traditionally credited as the founder of

a philosophical approach known as Taoism—though many modern scholars doubt that Lao-tzu was a single historical figure. For a variety of reasons, Taoism (also spelled Daoism) is difficult to define precisely. Over the centuries, as it evolved, Taoism came to influence thinking in various spheres of Chinese life—social, political, religious, and cultural as well as philosophical. One popular belief associated with Taoism is that a power or energy (*qi* or *chi*) suffuses and flows through all things in the universe, living as well as nonliving. Human beings can live harmoniously by finding and following the Tao (the "way" or "path"), which embraces the balance of opposites that make up the universe.

These opposites are referred to as yin (the female principle) and yang (the male principle) and include such dichotomies as hot/cold, light/dark, and sun/moon. Nature can teach humans the way to finding the proper balance, which in turn creates harmony and goodness, but this occurs more through intuition than through conscious striving on the part of humans.

The reverence for what nature can teach is the foundation for the great Chinese landscape paintings to come almost 1,000 years later. Artists would go to the mountains, camp for months to absorb nature's essence, and then finally paint the meaning of what they had learned of the Tao.

The sixth-century B.C. philosopher Lao-tzu is traditionally credited as the founder of Taoism, a mystical philosophy emphasizing harmony in nature and unassertive action.

Although there were frictions between the followers of the two famous philosophers, the great mass of Chinese accepted both schools of thought, even though they seemed to be opposite—duty, learning, and rigid adherence to rules as a way to mitigate the darker tendencies of human nature versus unassertive action and a deep, emotional relationship with nature as a way to tap into the essential harmony of the universe. Rather than fight to the death over these competing worldviews, Chinese culture pragmatically made room for both. In the arts Confucianism and Taoism produced two distinctive currents: an emphasis on honoring and reproducing the work of the old masters and an emphasis on individual feeling and self-expression. Both of these currents are represented in Chinese art through the ages and even now influence Chinese artists and craftspeople. The interplay of these opposites has created an exciting and vital tradition in the arts of China.

The Idea of Dynasty and the Chinese Identity

Mountains on the west, desert plains on the north, and oceans on the east and south ring the landmass destined to become China. Although previous kings and warlords had exerted control over portions of this territory, it was not until about 200 B.C. that members of the Han people (the ethnic group that today makes up more than 90 percent of China's population) succeeded in uniting much of this naturally self-contained land in a stable empire. The Han dynasty, as it is called, provided the foundation of the strong sense of identity that bound together the Chinese people (who refer to themselves as the people of Han) throughout the centuries.

The Han came to regard their realm as "the Middle Kingdom," a civilized land at the center of the world. Everything and everyone outside the large Han Empire was considered foreign and barbarian. Inside China, culture and the arts blossomed. Even in later years, when foreigners from the north and west conquered China, they generally found it wiser to adopt Chinese ways than to cling to their own practices.

When trade with foreigners brought new objects into the empire, Chinese artisans learned the techniques that had been used to make the objects. They then adapted these techniques to a Chinese sensibility. An example is the blue-and-white pottery that originated in Persia. In Chinese workshops this evolved into the exquisite Ming blue-and-white porcelains so prized by collectors of yesteryear and today.

Anyone fortunate enough to view a great deal of Chinese artwork will begin to recognize that it has a special quality, one unique among the world's arts. The story of how this fascinating artistic tradition developed begins in prehistoric times.

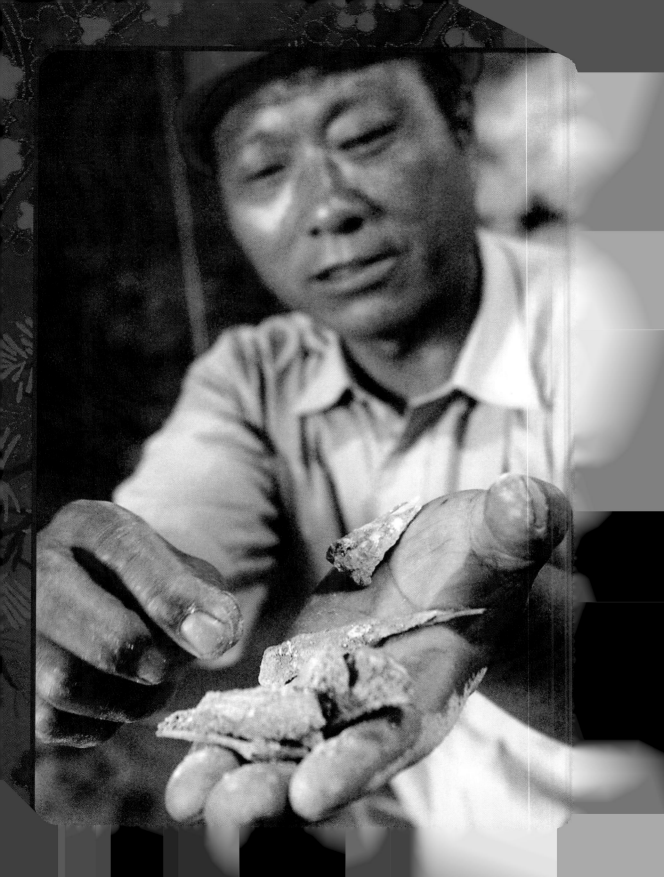

A Chinese paleontologist displays 25,000-year-old human bones from a cave at the Zhoukoudian site near Beijing, July 2003. Zhoukoudian is where "Peking man" fossils were found in the 1920s and 1930s.

2

Prehistoric Art and Architecture

The Yellow River basin, like the African plains, was a habitat of early hominids. In the 1920s, paleontologists discovered 400,000-year-old bones near Beijing, the capital of modern-day China. Dubbed "Peking man" (after the way English-speaking people of the time spelled Beijing), the fossils were later classified as *Homo erectus*, a species believed to have split from a common ancestor of modern humans more than 1.5 million years ago. In China, as elsewhere in the world, *Homo sapiens* (modern humans) eventually displaced the other human species.

Neolithic Societies

Archaeologists have uncovered remains of early Neolithic Chinese villages dating from 4,000 to 7,000 years ago. Settlers in these villages made stone tools; domesticated pigs, cattle, and dogs; farmed millet (a small round grain that cooks up like hot cereal); and made clay pots. Their huts and villages

provided protection from bad weather and from invaders and wild animals.

The first Neolithic people in the region that is now China dug into the ground to make their homes. The dugout floor and the pit walls of these structures were made of tamped earth—earth pounded flat and hard with smooth rocks. A shallow fire pit was dug in the floor, and sometimes storage cubbyholes and ledges were carved into the mud walls. Above the dugout floor and subterranean wall was a lean-to roof made from connected wooden poles covered with thatch. Amazingly, these early Neolithic people discovered that if they made a hole in one pole and sharpened the end of another, the two poles could be connected and would stay together even if the rope tying them became loose. This is the earliest known example of "mortise and tenon" joinery, a key characteristic of the complex and beautiful Chinese architecture that was to come.

The large hut in the center of the village was the tribal leader's house and also served as the place for communal gatherings. In early Neolithic times, the leader appears to have been a woman. This matriarchal arrangement mirrored that of many fledgling social groups in the ancient world. Even in the earliest Mediterranean civilizations of Greece and Asia Minor, the key gods and rulers were female. Only when social groups became more dependent on warriors, for defense and conquest, did the early gods and rulers shift into male beings.

A Chinese village during early Neolithic times would be surrounded by a ditch that had a single easily defended dirt bridge crossing it. Within the encircled area there was typically room for about 120 living huts, with separate areas for animal pens and food storage.

By about 3000 B.C., the late Neolithic era, villages became larger and were surrounded by protective tamped-earth walls rather than ditches. Towns in perfectly square shape were built, reflecting the early beliefs that the universe was square. Square city walls were

to become a feature of all Chinese cities until the 20th century. In some of the late Neolithic excavation sites, archaeologists have found remains of a high, tamped-earth platform in the center of the town. These early platforms call to mind the later Chinese tradition of building the emperor's palace on a raised earth platform in the center of palace towns.

Homes were soon built aboveground with a high door threshold to keep floodwater and rain out of the living area; this is a feature of traditional Chinese homes even today. Larger homes, with several rooms and a rudimentary center courtyard, have also been discovered. The scholars Robert L. Thorp and Richard E. Vinograd, in their book *Chinese Art & Culture*, suggest that these could have housed as many as five families. These family compounds seem to be the forerunners of the large family compound houses with multiple courtyards found in the Chinese civilization to come.

Throughout Neolithic times, children were buried in pots near the hut, whereas adult graves were located outside the village in large graveyards, possibly shared by several villages. In these graves, the body was laid on its back and the head turned to face northeast (archaeologists don't yet know why). Various objects were buried in the grave along with the body. These objects are the earliest examples of Chinese art that can be examined today.

Grave Objects

Grave objects can be a rich source of knowledge about ancient cultures. The earliest graves contain natural objects, things people would have found in their environment. In an early Neolithic grave discovered in China in 1987, for example, patterns of river shells lay on either side of the body, facing away from the head. One shape seems to be a tiger, and the other is surely a dragon. It is known from written records that 2,000 years later the Chinese believed the dragon to be master of the East and the tiger to be

master of the West. Furthermore, the dragon in the Neolithic grave has five-clawed toes. In later Chinese society, only the emperor could have decorations with five-toed dragons; everyone else's dragons had to have fewer clawed toes. Could it be that the Neolithic burial was the grave of a very early clan ruler? Without written records it is hard to be sure what the symbolism meant, but elements of the Chinese culture that was to develop from these beginnings are clearly evident.

A grave that contains objects crafted by people, as opposed to natural objects, can be an especially important find. Fabricated objects can help scholars gain insight into the aesthetic sense, technical ability, and even way of life of the early people. It is believed that many of the objects found in graves are just like ones that were used in everyday life. But, not surprisingly, buried objects have a much greater likelihood of surviving intact from ancient times, which is why the material culture of very old societies is often known primarily from grave objects.

Pottery vessels were very important to early cultures throughout the world. People in settlements near clay deposits invariably figured out how to make long coils of clay, and then wrap

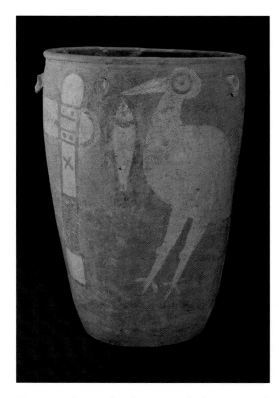

Pottery from the late Neolithic period in China was often decorated with realistic images of animals. This example is from the area of present-day Henan Province.

these coils into circular shapes to fashion bowls and jugs. These coiled shapes were then smoothed and dried in the sun. When these vessels were used in cooking, the people would discover that the pots became harder and more durable after "firing." The people would also discover that different-colored soils could be mixed with liquid to make paints for decorating the pots.

Many beautiful painted pottery objects from Neolithic times have been found in China and are displayed in museums throughout the world. These objects bear a striking resemblance to Neolithic pottery from other regions; in fact, all early Neolithic pottery tends to look similar, regardless of the area in which it was produced. Various geometric swirling patterns in earth colors seem to be the first way early people expressed themselves. It took some time before the clay arts in various parts of the world developed in different artistic directions because of the differing beliefs and skills of the artisans who made these objects.

In China during later Neolithic times, realistic fish and animals were painted on the pottery. Some of the lizard-like animals are thought to be dragons, but they could have been alligators, which were plentiful in the rivers at that time. In fact, since dragons in Chinese culture are not fierce monsters as they are in Western culture, but are more or less friendly river spirits, it could very well be that the symbol of "dragon" originated with simple river alligators. Using black clay, artisans of the Hemedu culture learned to make animal designs with a pointed object, and then to smear the incised lines with white paint. These pots are starkly graphic but not what would be thought of as very "Chinese looking."

Numerous shallow bowls with fish designs painted around the rim have been found in the middle Neolithic village of Banpo. The largest rim design on each bowl has a face with horns or possibly decorative feathers, and various arrangements of stick-figure fish on either side of the round face. The archaeologist Corinne

Debaine-Francfort, in her book *The Search for Ancient China*, thinks these different face emblems are family crests, used to identify the owners of the bowls. She also points out that these designs appear to be precursors to writing.

In the Longshan region during the late Neolithic era, a very "Chinese-looking" type of object suddenly emerges. It is thin black pottery, made with a potter's wheel and not with coils. The surface is not decorated, but is burnished smooth. In the best pieces of this pottery—which is referred to as eggshell ware—the sides are as thin as one millimeter. These ancient objects reveal a graceful form and astounding skill, characteristics that were to become an important part of Chinese art throughout the centuries. Even today, Chinese art typically emphasizes the astonishing skills of its creators.

Jade objects form another category that would become a unique element of Chinese art. Jade stones are particularly hard and are extremely difficult and time-consuming to carve. Especially in the northern and eastern regions, jade was prized. In pre–Bronze Age graves, archaeologists have found many pieces of jade—jewelry, round and "pig-nosed" discs (shaped somewhat like a teardrop with a center hole), *congs* (long squared-off cylinders with a center hole through the length), and amulets. Jade seems to have been considered a protector. In one instance, an entire suit made of small plates of jade, strung together with gold wire, was fitted over the body of a man who may have been a local chieftain. The Chinese have continued to think of jade objects as good luck protectors.

Ancient bronze ritual vessels are another high point in the story of Chinese art. The Chinese have prized these items, passing them down from generation to generation, displaying them in ancestor temples, and offering them as the most precious gifts possible to important people or as thanks for special favors from the gods.

Bronze is a metal made in a complex process of mixing copper, tin, and often traces of other metals such as zinc; the molecules of

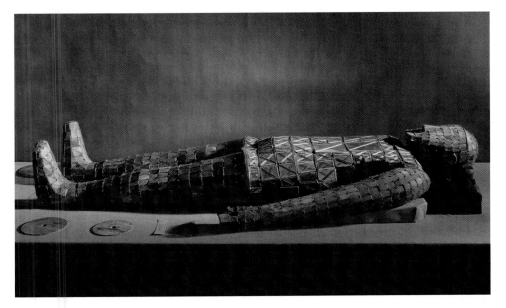

This jade funeral suit, found in a Han dynasty tomb from the late second century A.D., may have as its ancestors pre–Bronze Age burials. Jade has traditionally been viewed as a good luck protector in China.

the mixture bind together into what is called an alloy. Bronze technology was perfected in the Middle East around 2300 B.C. Art historians originally thought that around 1700 B.C., the early Shang people of China learned the technology from that region because the Chinese objects that were known up until recently were technically advanced and seemed to appear suddenly in China. Recently, however, cruder bronzes were discovered in sites dating to as early as 2200 B.C. This has led some historians to suggest that the Chinese invented bronze independently of the Middle Eastern cities 5,000 miles away. These historians also point out that the Chinese made bronze differently from the Middle Eastern artisans. Whereas in the Middle East, artisans used a technique known as the lost-wax method, the Chinese employed what is called the piece-mold method.

Bronze war implements were cast in Shang foundries and enabled Shang warriors to conquer vast regions whose peoples had only

Bronze weapons like this battle-ax helped Shang warriors conquer peoples who had only wood and stone weapons. This specimen—decorated, as were many Shang weapons—dates between the 18th and 16th centuries B.C.

stone and wood weapons. Although the bronze weapons were often decorated, the most artistic attention was spent on the ritual vessels. These Shang ritual vessels are resplendent in design and decoration. They are unique in the entire world and fetch hundreds of thousands and even millions of dollars in the major art markets today.

Ritual music had appeared by the late Bronze Age. Bronze bells were cast and played to invoke the spirits. These bells did not have clappers, like Western bells, but were struck like gongs. Each bell was calibrated so the center produced one tone and the side produced a slightly higher tone. Chinese music historians have reconstructed some of the music that was played on these bells. Tourists

visiting the Hubei Provincial Museum at Wuhan can go to concerts played on a reproduction set of ancient bells copied from the bells discovered in a noble's tomb near the city.

A unique and mysterious design called a "taotie" was a key feature of the surface decoration of almost all of these ancient ritual bronze objects. Art historians generally call it a "monster mask." There are many versions of this design, but all have staring eyes, curved horns, and a mouth. Some think it could be based on a water buffalo, which became domesticated around this time. Perhaps it might have derived from the Neolithic man-with-fish emblems found on the early pottery bowls, or from various sources. In any case, no one yet knows for sure what the taotie design—which often seems hidden in a mass of decorative lines—is meant to represent.

Archaeology and Recent Discoveries

One of the most exciting aspects of prehistoric Chinese arts is that few of the early sites have been fully explored. Chinese archaeologists have only scratched the surface, so to speak. Major discoveries are still being made even today.

FAST FACT

The contemporary Chinese composer Tan Dun, who composed the sound track for the movie *Crouching Tiger, Hidden Dragon*, played a special concert in 1997 using some of the ancient bells preserved in the storage vault in the Sackler Museum in Washington, D.C.

An example is the strange Sichuan culture discovered in 1986. The remote Sichuan Province had always been overlooked because of the prejudice that the region was a bit of a cultural backwater; the people, it was believed, had remained primitive until they were conquered by imperial Chinese armies and civilized by the Han Chinese. When modern-day peasants who were digging a well found and reported ancient objects, Chinese archaeologists rushed to the site. What they discovered was a huge pit whose contents seemed to have been burned in a ritual sacrifice. Included in the remains were many elephant tusks, monumental bronze statues with bug-eyed visages and large ears, and other strange and sophisticated bronze artifacts. Many of the bronze faces were gilded (covered with a thin overlay of gold)—a practice unusual among the early Chinese cultures.

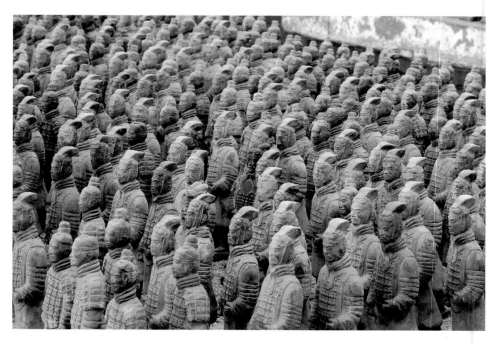

This photograph shows only a small portion of the terra cotta army that surrounded the tomb of the first Qin emperor near Xi'an. The life-size figures are rendered with extraordinary realism.

Another recent discovery is the life-size terra cotta Qin army discovered in 1974 near Xi'an. It was always believed that the low hill northeast of that city was the first emperor's tomb. But no one suspected that, surrounding the tomb for a length equivalent to several football fields, was a life-sized terra cotta army standing guard for eternity. Again, it was a peasant plowing the fields who made this find. Each soldier is individually sculpted; no two are alike. Archaeologists have unearthed and restored only a small portion of what they believe is buried—the army had been smashed in the peasant rebellion that overthrew the Qin dynasty. But work goes on each day, and eventually the entire ancient army will be repaired and on display. Even now tourists can visit the many soldiers and even chariots that have been repaired under a protective bubble building outside the city of Xi'an. Chinese archaeologists next plan to explore the emperor's tomb under the mound and, after that, what is believed to be the tomb of the empress in a smaller mound a short distance away.

The Qin emperor is considered the first ruler to unite all of China. Subsequent dynasties developed the idea that the government administrators assigned to rule these vast lands should be selected on the basis of scholarly capability. This evolved into the tradition of the Three Perfections: calligraphy, poetry, and painting.

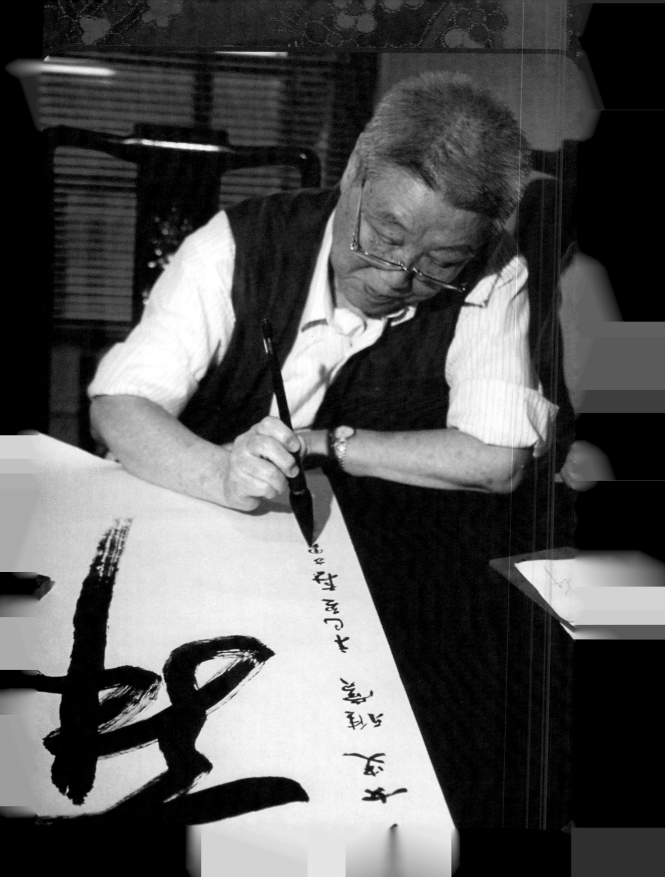

A modern-day calligraphy artist at work. Chinese pictogram writing dates back some 3,500 years, and the tradition of beautifully rendering symbols has long been among China's most respected arts.

3

Calligraphy

Writing began early in China. It evolved, beginning around 3,500 years ago, from picture emblems and signatures, to pictorial questions for the gods to answer, to clerical government records written with brush and ink, to poems and stories written in standardized or inventive characters. Amazingly, the same Chinese writing forms have been used continuously to the present day. Calligraphy, making the characters beautiful and developing artistic variants of the standard characters, became a major art form, and this first "perfection" is still pursued today.

Early Writing

Archaeologists have found pictures and signature emblems scratched on ancient pottery and bronze objects. Some depict objects that are readily recognizable. On one prehistoric Chinese clay vase, for example, a crudely rendered sun and crescent moon are

placed directly above a representation of jagged peaks. While it's not hard to distinguish the three natural elements—sun, moon, mountains—it's impossible to say precisely what this simple picture means. Is it a rudimentary representation of three important gods? Or does the picture indicate a span of time in a mountainous location—perhaps how long it would take to cross a mountain range? Does the image refer to a specific event—maybe the conquest of a mountain tribe, symbolized by the number of days of fighting? Without context, the meaning cannot be known.

But pictures can be used to communicate a clearer, less ambiguous meaning when the pictures are strung together and each represents a single idea or word. For example, two lines could mean the number two, the moon could signify "month," and a monkey could refer to a particular year (there are 12 such animals in the Chinese calendar cycle). Thus the three elements, strung together, might denote the second month in the Year of the Monkey and could be used to specify when an important event took place. This

stringing together of pictures is the origin of Chinese writing. When the pictures themselves evolve into more stylized representations of the original pictures, they are called "pictograms." By the late Shang and Zhou dynasty around 1500 B.C., the original picture writing had already evolved into pictogram writing. The bronze ritual objects from that time were often inscribed with pictogram words.

In the late Shang dynasty, kings had their scribes write questions for the gods on ox bones or turtle shells. After a question had been written out, a red-hot piece of metal was applied to the bone or shell, and the cracks that appeared were interpreted as the answers from the gods. The scribe then wrote down these answers on the cracked bone or shell. Later, how the answers were verified by actual events was also recorded. Many of these ancient writings have

Chinese seal stones are still used to sign and decorate letters and other papers. The seal script dates to the time of the Qin dynasty, which first unified China in 221 B.C.

been translated today. Scholars have compiled a dictionary of more than 6,400 Shang pictogram-words.

China was first unified in 221 B.C. by Qin Shi Huang Di. Although the Qin (pronounced "CHIN") dynasty would last only about 15 years, it established the framework by which succeeding dynasties ruled China. Shi Huang Di proclaimed the first national standards in writing; he ordered that the single form used by his scribes replace the many pictogram forms in existence throughout his empire. He did not create a different way of writing, such as a short alphabet representing sounds, as is used in the West. Writing in the Qin empire was still pictorial, with a pictogram equaling a complete word or idea. Shi Huang Di merely established the official "universal" form of the pictograms.

The Qin emperor's standard, which has remained in use for more than two millennia, is today called "seal script" because it is the form used for seal making. A seal is made by carving words onto the flat, usually square end of a special stone. Usually the seal stone is small enough to fit in a hand. Because a single character represents a word, it is possible to fit what is needed onto the small surface available. A version of seal script, called "small seal script," pushes the standard "large" seal characters into compact square shapes to more easily fit them onto the seal stone. Usually the words on the seal are the name of the seal owner. Sometimes a special day or event is carved. The carved end of the seal is dipped into vermilion-colored paste, and then imprinted onto documents or paintings. The making of seals requires such skill and sense of design that seal making is often considered the "Fourth Perfection." Seals are highly prized, and are used even today to sign and decorate papers.

Books since early Shang times were written on strips cut from the sides of bamboo poles. The pictograms were inscribed from top to bottom on the narrow strips. The collection of strips that made up

a book was tied together. To read the book, the bundle was untied and the strips were laid out from right to left. Shi Huang Di wanted to rewrite history to stamp out the memory of earlier kings and to establish himself as the founder of Chinese civilization. So he ordered all the existing bamboo books (except how-to manuals on medicine and agriculture) burned. This is the reason some historians call pre-Qin eras "prehistoric" (pre-writing). Writing existed, but nearly all the records were lost in Shi Huang Di's book burning.

Standardized Calligraphy

The Han dynasty reunified China after the peasant uprising that overthrew the brutal Qin rule. The new Han rulers decided that the best way to govern the vast empire's lands was not to dispatch soldiers to distant provinces to enforce order under the threat of the sword, but rather to create a class of scholar-administrators who would carry out the emperor's orders everywhere. Eventually, scholars had to pass difficult exams in the Confucian

FAST FACT

The Chinese invented block printing around A.D. 600, almost 900 years before the Gutenberg Bible was printed in Europe. Seals had for many centuries been imprinted on documents, often in sequence. The Tang Empire Chinese figured out how to make blocks of carved characters, like many seals together, which they printed to make numerous editions of religious and literary works.

Mao Zedong's People's Republic, founded in 1949, chose the Beijing dialect as the official spoken language for China. This official tongue, Putonghua ("ordinary people's language"), is sometimes called Mandarin in the West. Mao, who did not come from Beijing, did not speak the dialect. But written language everywhere in China had always used the Han characters. Even though people from different regions spoke different languages, they all used the same pictograms for the same objects or ideas. Today, though there are still many spoken languages in China, they are all expressed by the same Chinese characters. In fact, Chinese TV and movies have standard simplified-character calligraphy subtitles so that viewers who don't speak the Putonghua dialect can still understand the program. Although Westerners often think China would be better off switching to a short alphabet to make learning to read and write easier, the Chinese do not want to give up their huge unifying concept—everyone in China can communicate by writing on a paper pad, even if they cannot converse together with spoken words.

rules of good behavior and in writing. This way only those who knew the rules and could read official orders and write accurate letters and records would fill government posts. The exams were open to anyone, so even a poor peasant could aspire to the high status and comfortable lifestyle of a scholar-administrator. Writing and learning became all-important to Chinese society from this time on.

To replace the bulky bamboo strips, paper was invented in the Han workshops around 100 B.C. Brushes dipped in black ink were used to write on the paper. The Han court developed a new form of

writing that made the seal script pictograms faster to write with brush and ink. This new script was called "clerical script" because all the government clerks and officials used it. Characters were brushed on the paper from top to bottom and right to left, as if there were still bamboo strips underneath.

Writing became more and more popular among the educated classes. Emperors and nobles would relax by meditating on nature and then expressing their exalted feelings through calligraphy. Scholars would vie with one another to make the most artistic characters.

By the end of the Han dynasty, around A.D. 220, the earlier clerical script had been refined into the standard "classical" characters. All formal and literary works for nearly 2,000 years were written in these classical characters.

Beginning in the 19th century, China fell under the military and economic domination of foreign powers. Chinese leaders and reformers recognized that, if China were to compete with the industrialized nations, its people would have to achieve higher levels of education and literacy. The reformers believed that the complex and somewhat archaic literary classical script stood in the way of this goal and should be recast into a script that was easier for everyone, even adult peasants and factory workers, to learn. After World War II, when the Communists under Mao Zedong triumphed in a civil war against the Nationalists and established the People's Republic of China, a simplified script was introduced. (For political reasons the Chinese of Taiwan, where the Nationalists fled at the end of the civil war, continue to use the classical characters.) Although some people think of the simplified script as just classical writing with some strokes eliminated, it also includes some extra characters to help clarify meaning. It is, however, one more evolution of the original pictogram writing that originated more than 3,500 years ago.

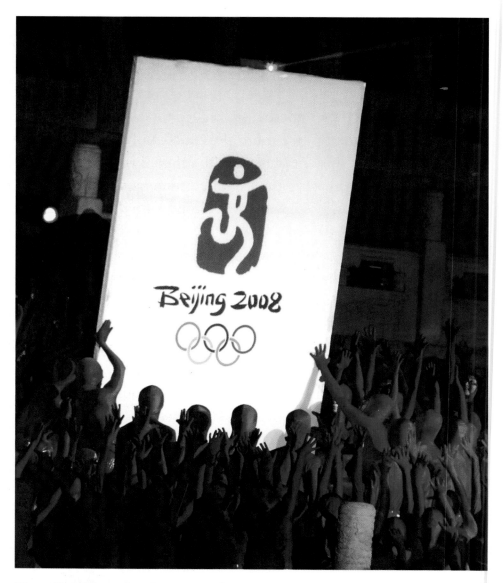

The official logo for the 2008 Olympics provides an excellent example of Chinese artistic calligraphy. The "jing" character from *Beijing*, the host city, has been rendered in a manner that suggests an athlete in action.

Creative Calligraphy

As was evident from the earlier discussion of Confucius and Lao-tzu, Chinese culture tends to be an amalgam of opposites. On the

one hand, calligraphers spent years learning to reproduce the standard forms with exactness. On the other hand, calligraphy masters were also free to express these forms with amazing inventiveness and creativity. At their best, these creative styles reflect inner truths and an appreciation of line for the sheer artistry of it. Sometimes the characters are barely readable (though they are always referable to the evolution of the original pictures and pictograms); as abstract art forms, however, the lines are beautiful and the forms can be studied and absorbed with visual pleasure. Some of these creative forms are running script and cursive script.

China is proud of its long tradition of artistic calligraphy. Just as emperors in the past painted calligraphy, contemporary leaders today practice and display their own calligraphy as an important personal art and as confirmation of pride in China's unique artistic culture. Mao himself wrote important state banners in his own hand's calligraphy. And millions of ordinary citizens today participate in this Chinese artistic tradition. Competitions are held frequently, and calligraphy is one of the most popular leisure activities in China, particularly among retirees.

Perhaps the most exciting evidence of the continuing vitality of calligraphy in Chinese artistic culture is the story of the 2008 Olympics logo. After Beijing won the right to host the 19th Olympiad, a competition was established for logo designers. The winning design incorporated the essence of Chinese calligraphy into the logo. Using the second character of the word *Beijing*, the character "jing" was decoded to the various seal, classical, and simplified scripts. The essence of the "jing" pictogram was modified into what is today called the "dancing Beijing" character—a symbol that looks like an active sportsperson who is running, happy, enthusiastic, and forward looking.

A poetry reading in Beijing, March 2003. Poetry, revered in China since ancient times, is considered one of the Three Perfections of Chinese art, along with painting and calligraphy.

4

Poetry

Poetry became the most revered type of writing in traditional China. Poems were the subject of the most artistic calligraphy. After thinking about a poem for hours or even days, the calligrapher would finally express his or her feelings about the poem by brushing characters with the form and creative energy that best reflected the mood of the poem.

The Tradition of Poetry

Verses have always been popular in China. When Confucius annotated the ancient mystical book *I Ching*, he included a collection of poems. Confucius is the principal influence on Chinese culture and society. He compiled a book of 305 poems, establishing the art of poetry as a worthy pastime in Chinese culture. Verses are also attributed to Lao-tzu, the traditional founder of the more liberal Taoist countercurrent—in fact, the "way" is described in a series of short poems.

Traditional poems used the devices of the Chinese language to create form—there would be parallel tones, parallel accents, parallel thoughts, and parallel rhythms. Every stylistic or content element required a balancing element for a perfectly formed poem. Courts and nobles would relax at night by drinking wine and challenging poets to compose short verses on the spot. Emperors and nobles with special regard for learning might compose their own poems. Calligraphers were commissioned to express the best of these poems in excitingly brushed poem scrolls.

Poetry became such an important part of educated life that a person could not succeed without some skill in writing poetry. Eventually the state examinations for government posts included the task of composing poetry in addition to mastery of calligraphy and knowledge of the books of Confucius.

Poems reflected the many different facets of Chinese life. Numerous poets (who were of course elite scholars) wrote about the common people. Partly this was following the example of Confucius's 305 poems, which were about the common people—their hopes and fears, successes and failures. Sometimes poets expressed wistfulness for what they imagined was a simpler, happier life. Other poets wished to expose the tragedies endured by the common people, in the hope that reforms would result.

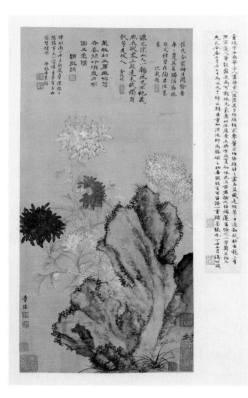

Nature provided the themes for many traditional Chinese poems, which were often incorporated into paintings. This work is from the 17th century.

Often, poems were disguised protests. In times of rebellion and turmoil, poets could write their disapproval by using symbols. A poem about an unyielding bamboo could be understood as a statement of defiance, but the poet would not get in trouble because it could not be proved that he was expressing defiance.

A special subject for Chinese poetry was the retreat to nature. Overburdened court and city administrators yearned for escape to the wilds of nature. Many scholar-administrators took extended journeys to the mountains, where they would follow the rhythms of nature in simple mountain camps. A traveler might meditate on nature's truths for months, and then express everything he had learned in a single poem. Some scholars who realized their government careers were over because of political changes, revolutions, or conquest became virtual hermits in the mountains. Some of the poems these displaced scholars wrote in exile are touching expressions of loss and homesickness.

Poems about romance and love were composed at various times. In the Warring States period (475–221 B.C.), many romantic poems were written. Lovers were often separated in the turmoil, and poems helped express the distress of lost love. In the prosperous

Song and Ming courts, where romantic alliances were fraught with political danger, many beautiful and elegant poems were written with word symbols of flower blossoms or ripe fruit. These symbolic poems were really secret love letters in verse.

Scholars have written poems throughout China's long history. Today, Chinese from all walks of life read poems and often try their own hand at composing poetry. A short verse or two is a challenging word puzzle—finding the words that will balance and counterbalance the tones and rhythms of the Chinese language. It is also an effective way to condense and express strong feelings or praise. Poems are the favored subject for calligraphy scrolls, which are frequently made and given as gifts. Poetry is indeed alive and well in China.

Three Famous Tang Poets

Wang Wei was a meditative poet who painted word pictures of the serenity of nature.

Deer Forest Hermitage

Through the deep wood, the slanting sunlight
Casts motley patterns on the jade-green mosses.
No glimpse of man in this lonely mountain,
Yet faint voices drift on the air.

—Translated by Chang Yin-nan & Lewis C. Walmsley

Li Bai was a leader of the romantic, passionate, "extreme feeling" school of poetry. He longed to live in an exalted spirit world rather than the mundane world of humankind. Here is an example of his poetry.

You ask me why I dwell in the green mountain;
I smile and make no reply for my heart is free of care.
As the peach-blossom flows down stream and is gone into
the unknown,

I have a world apart that is not among men.

—Translation found at http://www.chinapage.org/poem2e.html

Li Bai wrote what is possibly the most beloved poem to the Chinese today.

Night Thoughts

I wake and moonbeams play around my bed

Glittering like hoarfrost to my wondering eyes

Upwards the glorious moon I raise my head

Then lay me down and thoughts of home arise.

—Translated by H. A. Giles

In contrast to the soaringly lyrical Li Bai, Du Fu strove for complete realism. In his poetry he aimed to record events and feelings with almost historical accuracy. Here is an example from Du Fu's anthology.

Advent of Spring

The city has fallen: only the hills and rivers remain.

In Spring the streets were green with grass and trees.

Sorrowing over the times, the flowers are weeping.

The birds startled my heart in fear of departing.

The beacon fires were burning for three months,

A letter from home was worth ten thousand pieces of gold.

I scratch the scant hairs on my white head,

And vainly attempt to secure them with a hairpin.

—Translation at http://www.chinapage.com/poet-e/dufu2e.html#016

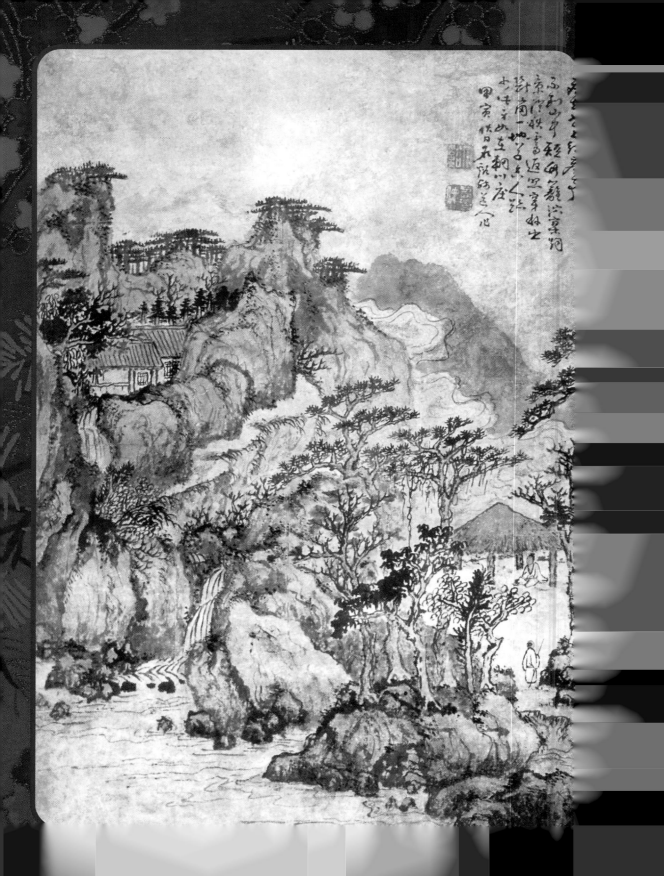

Mountain Retreat and Waterfall, by the 17th-century Chinese artist K'un-ts'an, contains the major elements of the monumental landscape painting that first developed earlier during the Tang and Song dynasties: mountains, water, and an indication of life.

5

Painting

Just as a calligrapher used a brush and ink to paint poems, the Chinese painter used similar brushes with ink and watercolor paints to paint pictures. The most admired artist was one who had mastered all the perfections and could combine these into unified works of art. The artist first would express the picture with brush and water-based paint, then write a poem in beautiful calligraphy near the picture, and finally complete the whole effect by imprinting vermilion squares with the artist's, and often the owner's, seals.

The most educated artist-scholars were also poets, though it was always acceptable for painters to specialize, particularly if they worked in commercial painting workshops. In these workshops, seals were assigned to master seal carvers, poems were generally copied from anthologies of the master poets, and the painter concentrated on mastering the brushwork techniques of calligraphy and picture painting. For a

particularly important painting, such as one commissioned by an emperor, separate masters would paint the parts of the painting in which they were expert.

Methods, Symbols, and Meaning

The painter used the same materials as the calligrapher—a brush, ink, and silk or thin paper. When the painter wanted color, vegetable or mineral pigments were ground into water in the same way that the black ink stick was ground for calligraphy. Because the silk or specially prepared paper was very absorbent, the painter needed to work fast or ugly splotches would result. The painter could never correct a wrong stroke. Hence, many years of brush practice was needed to make perfect strokes each time.

A Chinese student of calligraphy learned to write by copying over and over the strokes of the character words in the correct shape and order. Similarly, the student painter learned to paint objects by copying the picture strokes made by master artists in the past. In 1679 *The Mustard Seed Garden Manual of Painting* was compiled by various Chinese artists and writers. This manual gave instructions on how to paint trees, rocks, mountains, birds, animals, pavilions—in fact, almost anything one might find in a Chinese brush painting. Only after the student artist had learned the traditional methods—which could take many years—was creative expression allowed. Many people today, both Chinese and non-Chinese, find the practice of these step-by-step examples relaxing and enjoyable.

The artist prepared physically and mentally for painting, just as an athlete would prepare for an important competition. In the actual painting session, the artist would slowly consider the blank paper and plan the entire composition mentally before touching brush to paper. Once ready, the artist would paint swiftly and surely. The quality of the line was what made a good painting. The line made by the brush was considered a living force, capable of revealing

both good and bad. Besides years of practice with the brush, the artist also needed to cleanse the spirit, as it was believed that bad character would be revealed in the brush strokes.

In the best paintings, the lines showed energy, grace, and artistry. A painting might consist only of lines—it need not have color added. If color was employed, it was used to fill in areas already expressed by the black ink lines. Usually the color was confined to delicate tints that helped accent or separate the different elements of the painting. Shading to model forms into a three-dimensional representation was not important as in realistic Western paintings. However, shading of the black ink in the line itself was prized for the subtlety and the visual interest it gave to the strokes. Shadows were also omitted, even in twilight scenes where shadows would be prominent in real life.

In the predominant school of painting, the *xieyi* (pronounced "shi-er-YEE"), the artist's goal was literally "painting meaning." As Kenneth Wilkinson explains in his book *Chinese Language, Life & Culture*, the principle was that the artist should express emotion and feeling, and not be restrained by reality. Artists were free to disregard perspective and proportion, since the aim was not photographic rendering. A few strokes, freely drawn, could express an entire universe in the best of these paintings.

After spending perhaps months in the mountains, meditating on nature and the spirit of humankind, a scholar-artist would compose a poem and paint the feelings produced by these meditative travels. The artist would not strive to render faithfully a scene that was physically before him, as the painting was not meant to copy nature, but rather to evoke nature. Just as the poet rearranged words for maximum impact, the artist was free to rearrange visual elements to make a more compelling painting.

In calligraphy, the reader knows what the underlying picture looks like, but the brushed character sign is actually a stylized

abstraction of the ancient picture and might not resemble it very much. Similarly, the artist aimed to paint a stylized abstraction in expressing picture objects. It was believed that in meditating on the lines and seeking to understand what they represented, the viewer of a painting would discover the essence of a feeling and an object's spiritual reality.

Because expressing deep meaning and feeling was the primary aim of the "painting meaning" school of art, symbols were often painted to allude to certain beliefs or emotions. Chinese readers were already accustomed to the concept that a single calligraphy character expressed an entire idea. So it was natural to paint a visual symbol to express a bigger idea. Sometimes several visual symbols were included in the same painting. This created a more complex series of ideas in the meaning of the artwork. Favorite symbols were the "Three Friends of Winter": the bamboo and pine (which remain green in winter) and the plum (which blooms in winter). Depending on the visual treatment and poetic context, a symbol could have different meanings. For example, the bamboo could mean unyielding self-control, or peace, or many descendants. Eventually an entire symbolic language was built up. It became popular for viewers of Chinese artworks to search for clues and hidden meanings in the poem words as well as the objects painted. Today, students of Chinese art can buy dictionaries of Chinese symbols similar to the flower symbol dictionaries printed in Victorian England.

Tang Dynasty Painting

From very early times, the Chinese utilized the brush to paint flowing lines on pottery. Mythological tales describe paintings, but these paintings have not survived. However, a few fragile paintings on silk have been found in ancient tombs. These early paintings already show a characteristic emphasis on line, as well as the use of symbols, such

as the dragon (emperor) and phoenix (empress). Paintings from the Han dynasty (206 B.C.–A.D. 220) mostly focused on people doing things in their homes and towns.

After the fall of the Han dynasty, the rise of Buddhism—which originated in India and was introduced into China during the first century A.D.—sent Chinese art in a new direction. Cave temples were covered with painted murals of the Buddha and the saints, reminiscent of the art of India. Many of these paintings were brightly colored with shades of blue and green.

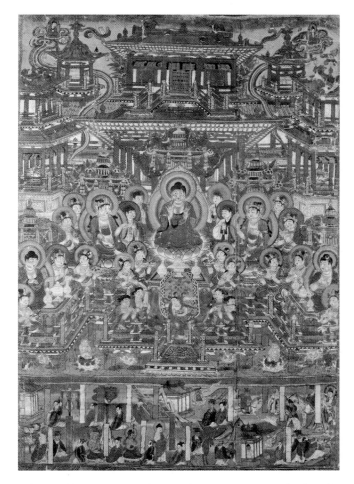

This silk painting from the Tang period clearly shows the influence of Buddhism.

Relatively few paintings from before the Tang dynasty (618–907) have survived, however. The Tang period represented a remarkable flowering of Chinese culture, and paintings from the era are among the most vital in the entire history of Chinese painting. Tang artists established the principles and key motifs that would influence the next dozen centuries of Chinese painting. Some of the most beloved Chinese pictures were created in Tang times.

The most far-reaching development was begun during the late Tang period (around 800–900) and perfected by Northern Song

artists (960–1126). Called the "monumental landscape," it took inspiration from the terrain of northern China, which contains numerous craggy mountains, waterfalls, rushing rivers, and pine forests. The monumental landscape followed a formula that was to become the foundation of nearly all landscape painting to come. It included three essential elements: mountains, at the top of the painting; water, in the middle; and an indication of life, usually near the bottom or in the lower reaches of the mountains. Typically the life element was a scholar in or near a pavilion; sometimes it was a fisherman, and occasionally a bird or animal. Sometimes the element of life was an empty hut or boat, which gave an ominous or mysterious meaning to the landscape. In this landscape convention it was understood that the top of the painting was the far distance, the middle was medium distance, and the bottom was the foreground; perspective (whereby objects in the foreground would be rendered proportionally larger than objects in the background, was not employed). Often the artist would make the life element so tiny as to be almost invisible, perhaps because he wished to express humility or society's lesser importance in the natural universe.

After the downfall of the Tang dynasty and a 12th-century invasion by a barbarian tribe that forced the Song rulers to move south, the vertical northern-style landscape formula was modified to suit the more rounded hills and flat flood plains found in the southern region. The late, or Southern, Song dynasty saw numerous horizontal scrolls painted, in which the mountains (actually gentle hills) were placed in one or the other upper corner; a calm, wide river or lake made up the bulk of the middle of the scroll; and the life element appeared in the lower corner opposite the corner containing the mountains.

Song Academy

In the refined and highly educated Song court (960–1279), all the arts were prized. In contrast to the symbolic, stylized, and majestic

landscape paintings prized by Tang collectors, the Song connoisseurs appreciated a new, delicately detailed, small-format realism. A painting academy was founded, and the style it exemplified is known as the "academic birds and flowers" school. Even emperors and empresses were accomplished masters; they painted some of the most beautiful examples of this school. All birds, animals, and flowers had symbolic meanings, so these paintings were painted less for the decorative value than to express a message or belief. Nevertheless, they are very beautiful and are eagerly sought by museums and private collectors worldwide.

Chan, or Less-Is-More Style

During the Buddhist revival toward the end of the Song dynasty, the painting of sages, saints, and philosophers became important. The Chan (or Zen Buddhist monastery) style stripped away all frills and visual devices, relying on a few powerful and strategically placed black-ink brush strokes to give life to the subject painted. The pose referred to an event in the life of the saint or sage, and the viewer had to be as well versed in the stories of these persons as was the artist who painted them. The goal of these paintings was to express the essential reality of the subject, and to help the viewer meditate on the spiritual truths involved.

But even without knowing all about the subject of a Chan-style painting, one can still enjoy it visually. The spontaneous, freely brushed lines have an immediate appeal. In contrast to the refinement and formality of the other schools of painting, the Chan school can be accessible and down to earth. Elderly sages look funny, as they must have in real life. Sometimes an animal, such as the monkey-king, was painted. Its antics and expressions seem almost forerunners to today's animated cartoons. Chan paintings often show a playful sense of humor, and they avoid pomposity. Besides being visual masterpieces, the best Chan-style paintings are easy to like.

Later Developments in Chinese Painting

The Tang/Northern Song monumental landscapes, the delicate realism of the birds and flowers school, and the minimalist aesthetic of Chan school paintings of saints and sages provided the foundation for much of the Chinese painting that followed. And the Three Perfections—calligraphy, poetry, and painting—continued to be combined into unified artworks. These artworks were all meant to express a belief or feeling and to be explored and meditated on by the viewer.

In 1279 the Mongols, a nomadic people from Mongolia who had already conquered the northern part of China, put an end to the Southern Song dynasty. The Mongol Yuan dynasty would rule all of China for 90 years. Although the Mongols preferred living in their own nomadic style, even in the capital city (present-day Beijing), they were great admirers of Chinese art and culture, and they encouraged the conquered scholars and artists to work for them. Many Chinese artists refused to serve in the government of the conquerors and wandered the mountains as scholar-hermits. Their artwork and poetry is full of impassioned longing and loss. Chinese artists who did work for the Mongols painted with fresh vitality as they adapted Mongol tastes and requests to traditional Chinese painting formulas. Among the most vibrant of these works are scenes of Mongols on horseback playing battle games on the northern plains. There is an unabashed enjoyment of life and art in most Yuan paintings.

After the Mongols were overthrown in 1368–1369 and the Chinese Ming dynasty was established, there was a concentrated effort to cleanse the arts of Yuan Mongol influences and to make them purely Chinese again. The scholars who had refused to work for the Yuan Mongols were much admired; they were contrasted with "professional" artists, who were accused of painting without feeling. The Ming period saw the development of "literati" circles,

groups of scholar-artists who did not serve in the government but were instead supported by wealthy benefactors. It was thought that, freed from the day-to-day concerns of affairs of state, these artists could concentrate on expressing feeling. The literati artists formed groups, and multiple artists often collaborated on the same painting. (In the homes of influential people, the literati artists were important assets for entertainment, and they became pampered celebrities in Chinese society.)

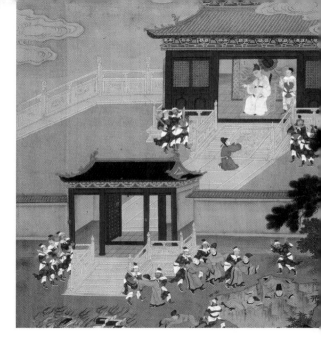

Although they readily embraced Chinese culture, the Manchu Qing emperors unwittingly helped introduce Western influences into traditional Chinese art when they invited Europeans into their realm. Note the bright colors and the solidity of the shapes in this Qing-era painting, which depicts the burning of books under the first Qin emperor.

The Ming scholars looked back in history and rediscovered past masterpieces and precepts. Each literati group claimed to know the "correct" painting style. Even though the idea was to express deep feeling, rules were followed exactly—the literati artists failing to realize that vitality in art often happens precisely when established rules are broken. Although the literati paintings at first glance call to mind Tang monumental landscapes, they tend to be overly detailed and fussy rather than truly monumental, displaying formulaic craftsmanship rather than impassioned meditative feeling.

The last dynasty to rule China was the Qing dynasty (1644–1911). Like the Mongols, the Qing (pronounced "CHING") were not Chinese. They were Manchu warriors from northeast of China. The Qing did not trust the Chinese scholars to continue running the government; instead they tried to install their

Perspective is characteristic of Western realistic art. Renaissance artists in Europe developed what is called mathematical perspective to make paintings appear more lifelike and realistic. The mathematical theory governed the relative sizes of distant versus near objects. Even a single object would follow the rules, the more distant portions appearing to become smaller, receding to a "vanishing point." Spatial perspective refers to painting nearer objects with sharp edges, and distant objects with softer edges and bluer tones. In addition to perspective, the gradual shading of colors and careful painting of shadows gives a three-dimensional impression to Western realistic painting.

own soldier-administrators, or bannermen, from the families of the Manchu tribes. They also considered foreigners more trustworthy than the conquered Chinese and invited such groups as the Roman Catholic missionary Jesuits to help rule. But in terms of the arts and everyday culture, the Manchu Qings enthusiastically embraced Chinese traditions. They compiled lists and protocols and collected art treasures. They learned to speak Chinese and practiced calligraphy. What they didn't realize, though, was that the Westerners they invited into their realm—notably the painter Guiseppe Castiglione (called Lang Shining in China)—brought a Western influence that was distinctly non-Chinese to painting. In Qing art, colors are brighter, details are clearer, and line is less important than in traditional Chinese painting. Shading begins to express shape, especially in the folds of clothes and facial features. Sometimes there is even a hint of Western-style perspective. The paintings from the Qing dynasty are often vibrant and appealing,

but they are an accidental mix of Chinese and European styles and techniques. They are not the pure, traditional Chinese artworks the Qing meant them to be.

Chinese Decorative Painting

Although unified "perfection works," combining painting, poetry, and calligraphy, were traditionally considered the highest art form in China, other types of Chinese painting should not be ignored. Some of the most stunning of these are the pre-Tang Buddhist cave paintings. Exuberant yet fervent, they show the heavy influence of India and Central Asia in their subject matter, colors, and painting styles. The Buddhist cave paintings contributed the blue and green color scheme to the monumental landscape paintings of the Tang and Northern Song periods, and they served as the models for the richly detailed wall paintings of nearly all temples and shrines in China for the next 1,500 years.

During the three centuries of Tang rule, a series of enormous wall frescoes were painted. Now on display in the Shaanxi History Museum, these frescoes make for a fascinating and beautiful record of Tang court life. The collection includes depictions of hunting activities, games on horseback that look much like polo, parties, and court ladies. In one fresco, foreign diplomats bringing tribute to the Tang court wait in line to greet the emperor. A close look reveals the long noses of the Westerners, the fur hats and coats of the Russian envoys, the camels from the Silk Road traders, and other interesting details. Historians point to the influx of all these cultures and foreign ideas as a major factor in the explosive advances in Chinese art and literature during Tang times.

Portraiture was an important genre of painting at least from Song times onward. The main portrait subjects were emperors and influential court figures. These portraits were done in a manner called "color painting," in which color and design were more important

This Tang dynasty fresco has been titled *Watching a Bird*, in reference to the woman at left. Various aspects of court life were depicted on the many frescoes painted during the three centuries of Tang rule.

than line and virtuosity of brushwork. It is believed that the portraits were not necessarily accurate likenesses, but that they were accurate in terms of colors, badges of honor, and other emblems of rank.

Except for decorative wall paintings and imperial portraits, paintings were not displayed, but were rolled and stored as family treasures and heirlooms. On special occasions, the owner would unroll and enjoy a painting with friends. Often, with a long scroll, only one section was unrolled and enjoyed at a time, making for an extended and enjoyable visit. Special occasions were also celebrated by using objects in a special art form the Chinese invented and perfected: exquisite porcelain and ceramic wares.

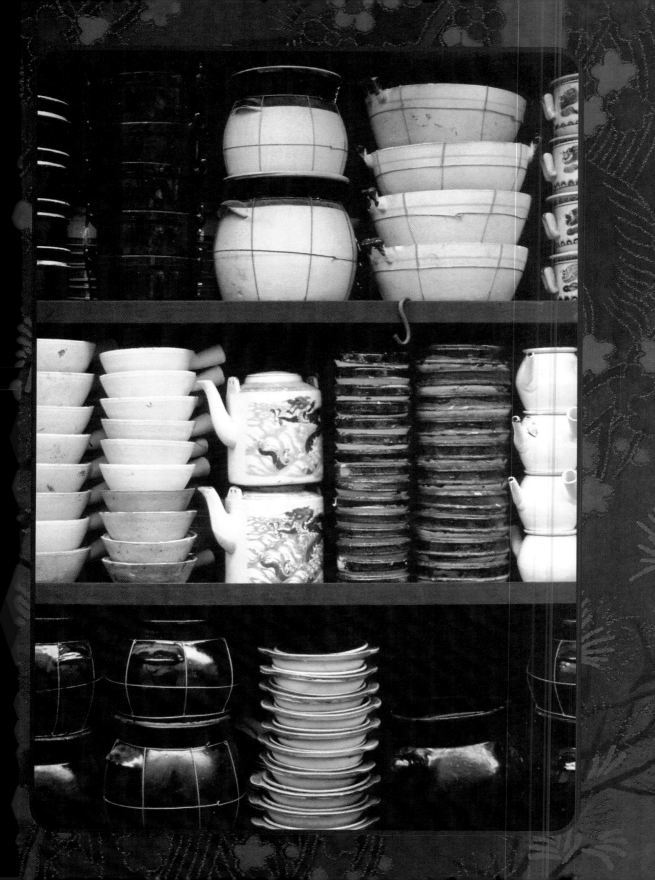

Ceramic dishware in various shapes and styles sits on the shelves of a Chinese store. China has produced some of the world's finest ceramics—a fact reflected in the term English speakers today often use to refer to any porcelain: *china*.

Ceramics and Porcelain

China has consistently created beautiful ceramics. Chinese potters were fortunate to have raw materials and technology available that enabled the invention of porcelain. Over the centuries porcelain making became one of the most important arts in China.

Methods and Materials

The terms *pottery* and *ceramics* are sometimes confused. Pottery objects are fashioned from kneaded damp clay, after which the object is sun-dried and then usually hardened at the temperature of a cooking fire. The walls of a pottery pot are typically ¼ inch to ⅜ inch thick. If they are too thin, the object breaks apart; if they are too thick, the object cracks as the outer edge shrinks while drying over the still-moist inner core. When clay soil is found in a region, most emerging cultures figure out how to make pottery.

Ceramics refers to any non-conducting, non-metal

heat-fired substance. Today many high-tech ceramics are used in industry, communications, and defense applications. When applied to art objects, however, ceramics generally means more refined types of pottery made of clays that can withstand higher temperatures and are therefore somewhat harder and less water absorbing than "soft" pottery. Stoneware, for example, is fired at 500°C (about 950°F). Art ceramics are generally decorated with glazes—glassy materials melted under the high heat of firing.

Porcelain is the height of ceramics art technology and was invented thousands of years ago by the Chinese. Porcelain is an extremely hard, naturally white pottery. It is translucent when held up to the light. If tapped like a bell, it gives off a clear, resonant tone the same way that a high-quality crystal wine glass produces a tone when tapped. Regular "soft" pottery and stoneware give off only mild thuds when tapped. Because porcelain is so strong after firing, porcelain dishes and vases can be fashioned with very thin walls— almost as thin as fine blown glass.

Porcelain begins with a mixture of kaolin (a very pure clay that hardens only at extremely high heat) and a small amount of feldspar (a mineral that, at the super-high heat of firing, melts into a clear glassy cement). The pureness of the kaolin clay makes the porcelain white, and the feldspar cement is what gives porcelain its strength and translucency. The temperature needed for firing is 1,500°C or more (about 2,750°F)—at least three times hotter than what is required to make stoneware.

Crude porcelains were made in early Shang times (1500–1050 B.C.), when bronze masterpieces were being fashioned. It is said that porcelain was invented to share the high heat used in making bronze objects. The Han period (206 B.C.–A.D. 220) saw further experimentation with the porcelain process. By the seventh century, in the early years of the Tang dynasty (618–907), the process had been perfected. From then on stunning examples of Chinese

porcelain art were produced.

China had the raw materials to support a fine ceramics and porcelain tradition. Porcelain stone and clay deposits were especially plentiful and of high quality near the imperial porcelain workshops of Jingdezhen, Jiangxi Province, in southeast China. Even farther east, the soft white clay from Dehua, Fujian Province, on the seacoast, supplied the unique material for the *Blanc de Chine* wares so popular in the trade with Europe.

In the early years, China had plentiful forests to provide wood for the fuel-greedy super-hot kilns. The Chinese had already invented the processes to create superheated fires for the making of bronze wares more than 1,000 years before the birth of Christ. They put this knowledge to good use in building high-heat kilns for firing porcelain. When the forests started to run out, the technologically inventive Chinese figured out how to adjust the kilns to use coal as fuel. As ceramics and porcelains became more and more popular, the workshop technicians invented numerous improvements and modifications to the processes, glazes, and designs to enable larger and more varied porcelain production.

Porcelains were lucrative for foreign trade, and they were used by the Chinese as everyday dishware. They were also highly prized as objects of beauty in the imperial courts and administrators' estates.

Important Styles of Chinese Ceramics and Porcelain

During the tolerant and culturally curious Tang dynasty, a dramatic style of glazing called *sancai* ("three colors") was developed. Amber, green, and cream-colored lead glazes were allowed to drip down the object during firing.

In the refined Song courts (960–1279), porcelain followed in the same direction as painting—becoming smaller and more delicate. The bright, dramatic, earthy Tang glazes were abandoned in favor of

delicate and subtle monochrome (single-color) tints. Large urns gave way to small, thin-walled bowls with lovely incised designs that are so fine the marks can barely be seen without strong viewing light. The shapes became gentle, serene, and exquisitely controlled. During the Song period subtle glaze effects (referred to by such names as oil drops and rabbit fur) were invented and treasured, and rare combinations of colors produced a harmonious and sensual feel. One example is Jun ware, in which copper was "thrown" (actually carefully applied to appear random) onto a bluish glaze before firing. The results are a lovely plum color over soft blue.

When the Mongols overthrew the Song dynasty in 1279, they instituted a brief but excitingly creative time in Chinese porcelains. During the nine decades of the Mongol Yuan dynasty, designers no longer were constrained by the dainty, subtle forms and mostly monochrome glazes of the Songs. They were free to design larger, fancier wares and to work with technical innovators of new kiln methods and varied glaze processes. Astute traders, the Yuan were quick to pick up on fashions around the known world. They noticed, for example, that the Persians and mosque builders of the Islamic religion favored white pottery and tiles decorated with dark blue designs painted with cobalt glazes. The Chinese had lots of white porcelain clay but little cobalt. So they imported cobalt mineral and started experimenting with blue-and-white designs to compete with the native Middle East blue-and-white wares. Even though relatively little Yuan ware was made, owing to the quick overthrow of the Mongol dynasty, the direction of the future of Chinese porcelains was set by their invigorating creativity. Decoration, especially in blue and white, became important. Fanciness came back into vogue, and eventually porcelain pieces included colorful enameled-on scenes of children playing and pretty court ladies.

The Ming porcelain makers produced vast quantities of blue-and-white ware, both for export across the Silk Road and for domestic

use. Collectors can date pieces by the shade of the white porcelain—whether tending toward ivory, pure white, or bluish white. The shade of blue produced is also used for dating pieces, as are the clarity and subjects of the decorations painted with the cobalt glaze. It is generally acknowledged that the Ming dynasty's porcelain factories produced the best blue-and-white ware of all time.

Another innovation from the Ming period was enameling after the porcelain was glazed and fired, which made possible a wider range of colors. (Applying a full palette of colors in glaze form was impracticable because at the high firing temperatures many colors

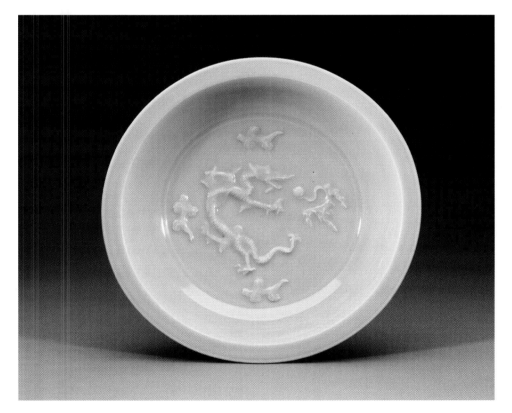

This elegant dish, which features a raised dragon design, bears the light green glaze known as celadon. Though graceful simplicity and monochrome glazing are characteristics of Song dynasty ceramics, this piece was actually produced during the Mongol Yuan dynasty, whose porcelain is remembered more for its multicolored fanciness.

would burn off.) Enameling with the full-color palette was perfected during the Qing dynasty (1644–1911). Entire workshops of porcelain enamelers were established, and painting on glazed white surfaces became a high art.

Chinese traders had always traded their porcelains with Southeast Asian merchants and along the Silk Road to the Middle East. During Qing times, they found vast new markets in Europe and the new United States. The Europeans especially were ravenous for the colorful enameled porcelains. The Qing designers, again with an eye to trade, developed a whole new class of wares suited to Western tastes.

The Chinese stuck to their own preferences for their own use, but they were unrestrained in creating what they considered flamboyant and exotic wares, in the sizes and forms used for elegant Western table settings and tea services. These commercial trading products are referred to as export ware. On these pieces the Chinese porcelain artists painted scenes with European trees and flowers, as well as men and women in Western-style dress. A bright pink rim with plenty of dainty bright flowers on the rest of the dish turned out to be very popular (this style is called *Famille Rose*). Wealthy Europeans ordered from China complete, custom-made table settings. Armorial export ware, as this porcelain is called, was made in the style and color the customer wanted, and frequently a noble family's coat of arms was painted on each piece in a setting.

A Ming-style blue-and-white vase produced between 1662 and 1722, during the first decades of the Qing dynasty. Note the different tones of blue.

In the age of sail, merchant ships carried heavy items (called ballast) in the bottom of their holds to help prevent the vessel from tipping over. With ships that traded in China, this ballast often consisted of low-cost plain white Dehua bowls and plates. Upon reaching port, whatever ballast items had survived the trip were sold. In the pottery center of Delft, in the Netherlands, a thriving business developed whereby these plain plates and bowls were painted with bright enamels "a la Chinoise"; the newly decorated "export ware" was then resold at a handsome profit. In the United States, Boston-based ship captains found that blue-and-white wares sold quickly when the ballast was unpacked. Although they were clearly not masterpieces, they were cheap and had a charm that appealed to the new nation. Today many of these pieces are treasured heirlooms and museum collectibles.

Two examples of export ware, produced specifically for the European market. The decorations and shapes would not have been seen on porcelain used inside China.

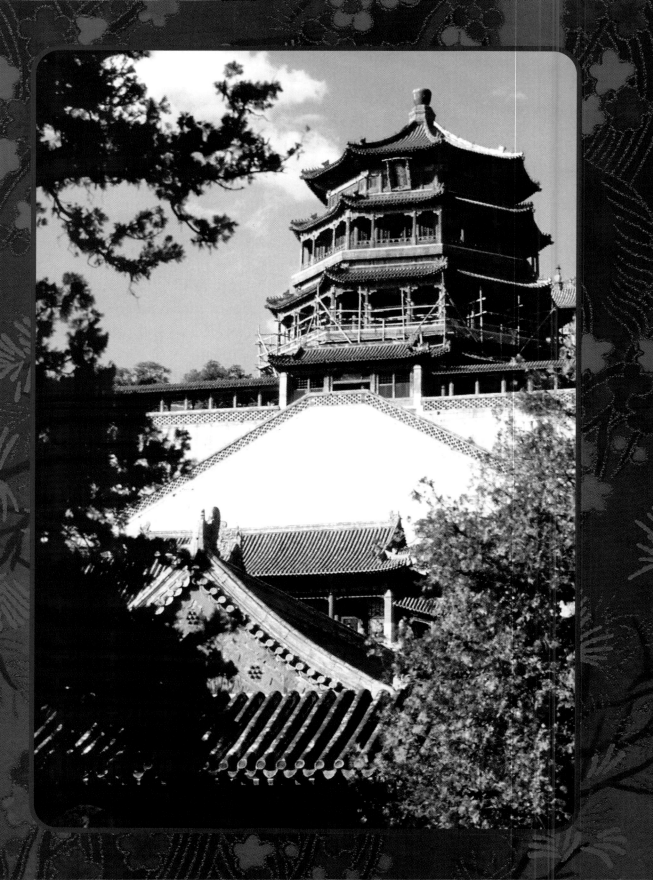

This temple, on the grounds of the Summer Palace in Beijing, bears many characteristics of China's distinctive traditional architecture, including the upward-curving roof and the multistory pagoda structure.

7

Traditional Architecture

For thousands of years, until the mid-20th century, Chinese architects built in a unique style. It was ideally suited to China's earthquake-prone terrain, the available building materials (plentiful forests and clay soil), and Chinese traditional beliefs and values.

Travelers can see numerous traditional buildings throughout the country, as many Chinese still live and work in such buildings. In addition, the government is restoring important examples of traditional architecture as part of its efforts to promote tourism.

Traditional Building Structure

A traditional Chinese building has three components: a tamped-earth platform or raised floor; a sturdy system of interlocking wood pillars, ceiling beams, and roof rafters; and a heavy overhanging roof supported by these rafters.

Because the wood "bones" of the building bear the

FAST FACT

Tamped-earth walls are made even today. Two sets of thin tree trunks are lashed together and placed side by side with a wide space in the middle. Loose earth is shoveled into the space and then pounded with rounded rocks. The pounding makes the layer compact and almost as hard as cement. More earth is shoveled in and pounded. This is done over and over until the tamped-earth wall reaches the right height. Then the tree trunks are removed, and the walls are smoothed and whitewashed or painted.

weight of the roof, walls are not load bearing as in traditional Western architecture. So walls can be anything the Chinese builder wants. A breezy garden pavilion will have no walls. A scholar's retreat might have walls of delicate carved filigree. A home usually has thick walls of whitewashed tamped earth to keep out the cold winter winds. Any desired walls are always added after the wooden bones of the building have been erected, and often after the roof is put on.

About 7,000 years ago, Chinese builders developed mortise and tenon joinery—putting a shaped end of one piece of wood into a hole cut in a different piece of wood to join the two pieces together. In the beginning, the pillars and beams were simple, and they sometimes had rope wrapped around the joints for extra strength. Over time, builders discovered that if they designed many interlocking shapes and poles, the structure would strengthen itself, and no nails, rope, or other reinforcement was needed. If the family wanted to move their house, they could disassemble it and put it

back together elsewhere like a giant puzzle. Also, this type of wood structure is flexible enough to withstand earthquakes, which are common in China. The walls might crumble, but the wooden frame and heavy roof stay put.

To protect the wood support pillars and the tamped-earth floor from rain, the roof in traditional Chinese architecture is large. The roof—usually made of interlocking curved earthenware tiles—is also made strong and heavy to keep evil spirits out of the building below. Simple country homes and ancient structures have roofs with straight lines, but grander city homes and public buildings typically have corners that curve up. The wooden rafter structure, made of many small interlocking pieces, is what makes this curve possible.

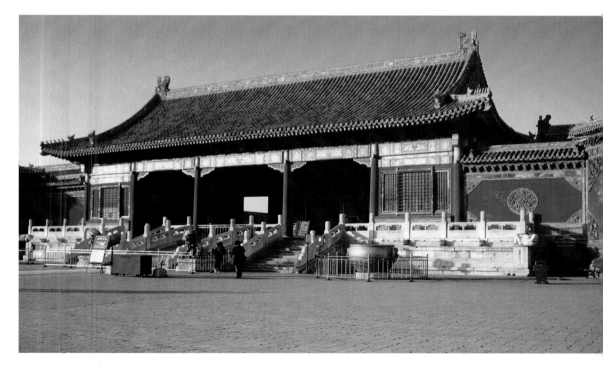

Chinese cities were surrounded by square defensive walls, and within the city limits the various wards were also walled off. Seen here is part of the Imperial Palace complex in Beijing's Forbidden City, where the emperors lived behind high, well-guarded walls.

Chinese Town Planning

The early Chinese believed that the world was square, and they designed their towns to be squares too. Roads were straight and crisscrossed at right angles like giant graph paper. Towns were oriented along the north-south axis, which was thought to be powerful. The ruler's home and government buildings were typically located in the center of the town, though occasionally they were situated along the north wall.

While walls were not important to traditional building design, they were vital to town design. Towns and cities were fortified places for urban activity. Tall, thick protective walls marked their outside perimeters. People could enter or leave the city only by going through massive guarded gates. Inside the main town walls, various square wards were set up, each defined by its own strong walls and entrance gates. The most important ward in the capital city was for the emperor and his palaces. Because no one could enter this ward except through the guarded palace gate, the palace inner city was called the Forbidden City. Other wards were assigned to specific types of people—nobles and important officials near the Forbidden City, and merchants, craftspeople, and workers in less desirable parts of the city. At night the gates of each ward were locked, and residents could not leave or enter their ward until morning.

Just as there were walled community wards within the main town walls, a family's house was like a miniature walled ward within the assigned town ward. Family homes, called courtyard houses, are really many small houses and modules grouped around one or more inner courtyards, all protected by a big outer wall. Large families with many generations, relatives, servants, and sometimes even farm animals lived within the family compound walls.

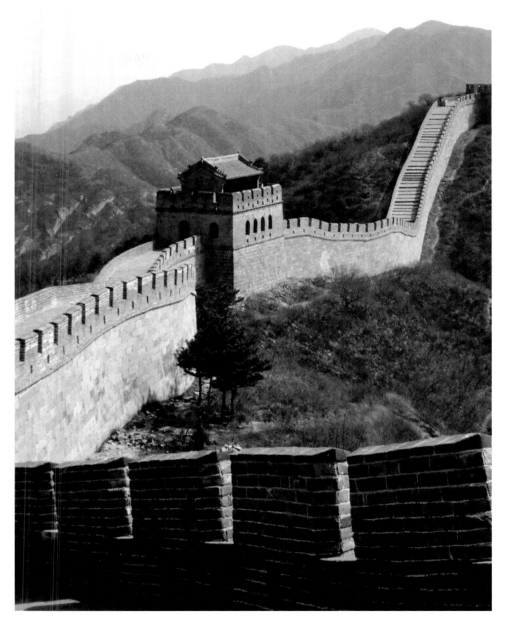

A section of the Great Wall of China. After the Qin dynasty united China in 221 B.C., it linked separate fortifications that had been constructed by several states, forming a formidable defense against invasion from the north. Successive dynasties up to the time of the Ming maintained, repaired, and extended the Great Wall, which eventually reached more than 4,000 miles in length.

Clearly, protection and security were important priorities in town and house planning. Watchtowers were put in the corners of the main town walls. Atop the towers, soldiers scanned the surrounding countryside for approaching threats.

Bigger watchtowers, called beacon towers, were built on strategic heights and mountains to further protect the citizens. Using smoke signals, soldiers in these distant beacon towers could warn the city guards in their watchtowers about approaching enemies. Sometimes several beacon towers were connected by protective walls for even better security. This was the origin of the Great Wall, which today separates Mongolia from the rest of China. The first Qin emperors, in the latter part of the third century B.C., built beacon-tower garrisons with huge connecting walls to keep Mongolian invaders out of the Chinese lands to the south. Under the Qin, the entire northern frontier was protected—a length of approximately 1,500 miles (about the distance from Boston to Miami).

Special Buildings and Decoration

In the Confucian world order, the emperor was the Son of Heaven and the father-protector of all the people. One of his duties was to pray for good harvests. Once a year, the emperor went to the Temple of Heaven, about a mile and a half from his palace in Beijing. At night he walked alone up the great steps of the circular mound and prayed. It turns out that this structure is a giant echo chamber. One can imagine the fear people waiting outside the temple must have felt when they heard the emperor's voice booming from the darkness. Today, this echo mound is a popular spot for visitors.

Chinese people believed that the spirits of their departed relatives remained on earth and could influence their lives. So it was important to give filial respect and keep the ancestor spirits happy! Within the family home, a special altar was set up where offerings of

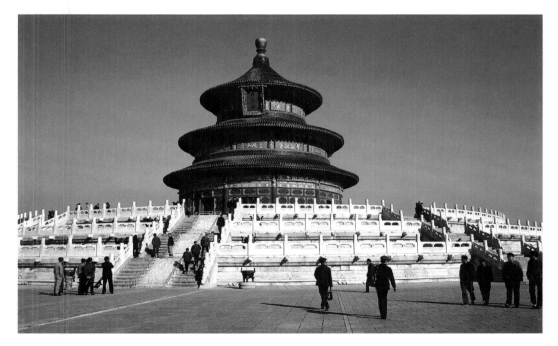

The Temple of Heaven, Beijing. It was here that Chinese emperors went once a year to pray for a good harvest.

favorite foods could be left for the family's ancestors. In a wealthy family, an ancestor temple would be built near the family graves. Some emperors ordered gigantic temples to be arranged over their own graves. A bronze tablet inscribed with the building plans of the king of Zhongshan's necropolis was discovered in the remains of his tomb. It said that a copy of the plans should be kept in the palace so that future kings would know how to build a proper temple complex for their own spirits. The plans show that traditional building structure on tamped-earth platforms was to be used.

The influence of Buddhism added a unique type of temple architecture to China: the pagoda. Derived from the stupa, a usually dome-like structure that houses Buddhist relics, the Chinese pagoda evolved into a lofty, multistory temple building. Each level has an altar to display Buddhist statues. Worshippers can climb up and pray on each level.

A great development in Chinese architecture took place about 900 years ago, when the court promulgated a building code that was to be used throughout the entire empire in the design of new buildings. Published in 1103, this book of plans and codes was called the *Yingzao Fashi*. It was highly detailed and gave drawings for everything that needed to be built. Sizes were specified, and everyone was to use these plans everywhere in China. This meant that beams and wood could be cut and shaped inexpensively in the mountain forests and delivered far away to the cities, ready to be assembled. If a specific beam in a house rotted or burned, its replacement could be ordered just by identifying it from the universal code book.

Eight ranks of building module sizes were specified, from great palace halls to small living modules for common workers. Everything was based on a standard-sized module. To make a building bigger, one just had to add appropriate modules. To change a building's use, one simply rearranged what was in the space below the roof. For example, a temple could be changed to a hospital by

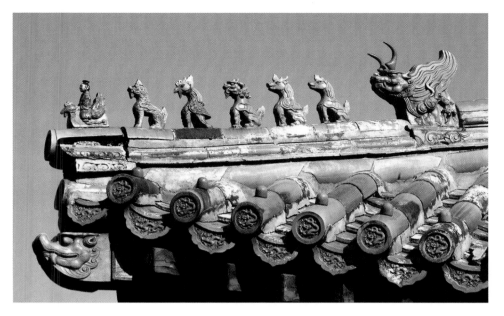

Roof guardians, fanciful figures placed on the corners of rooftops, were supposed to protect the inhabitants of a building against evil spirits from the sky. The number of roof guardians on a house indicated the social rank of its owner.

removing the central altar and statues and putting walls between the wooden structural pillars. Construction and repair of buildings all over the empire became streamlined and efficient.

The Chinese traditionally painted the wood timbers and rafters to help protect them from rotting. They liked bright colors and intricate designs. Red was a favorite color because it signifies good luck and wealth. The earthenware roof tiles were also glazed according to the official code. Tiles glazed blue were reserved for the emperor.

A traveler in China notices many small animal-like figurines placed on corners of the glazed tile roofs. These figurines, called roof guardians, are meant to give extra protection against evil spirits from the sky. In hierarchical Chinese society, the number of roof guardians was an indication of rank. The emperor could have eight or nine figurines per corner; nobles, six or seven; and families of modest standing, only one.

Stone sculptures of animal and human figures guard the "Spirit Way," the approach to the Western Qing Tombs, Hebei Province. These figures are reminiscent of the ones that line the roadway leading to the tombs of the earlier Ming emperors.

8

Sculpture

Chinese sculpture is rich and varied. Sculpture has played an important role in religious and ritual practices, as well as in everyday life. Surprisingly, however, relatively little has been written about this aspect of Chinese art.

Tomb Sculpture

Inside the tombs of ancient Chinese kings and nobles, archaeologists have found evidence that a retinue of slaves, servants, attendants, and usually the wife and concubines (essentially lesser wives) of the dead were killed and buried in the tomb alongside the king. As discussed previously, the Chinese believed that the spirit remained active on earth after death. So it was natural to suppose that spirits needed their friends and servants with them after death.

The earliest Chinese sculptures seem to have been statues that functioned as stand-ins for the people who would otherwise have been killed and buried with a

ruler or important official. The first Qin emperor seems to have wanted his entire army with him in the spirit world. But even he wouldn't be able to sacrifice an entire army, so he set up a huge workshop near the site of his future tomb. In this workshop, life-size terra cotta replicas of each soldier and officer, including the cavalry's horses, were sculpted and painted, ready for burial at the emperor's funeral. As has been noted, these are very realistic sculptural portraits, and no two are identical.

By Han times (206 B.C.–A.D. 220), it was usual for even ordinary people of means to be buried with small pottery figures, usually about 7 to 15 inches high. Not only were people included, but so were farm animals, a replica of the owner's house, and auxiliary buildings—important assets to be used in the afterlife.

During the Tang dynasty (618–907), the tomb figures reflect the wealth and diversity of that vital artistic age. They are larger—around three or four feet tall—and glazed with the dramatic *sancai* (three-color) glazes. Hence the colors are still fresh and bright, in contrast to the Han pottery figures, whose paint has worn off. Horses, warrior bodyguards, and even an occasional camel that would have been used in trading along the Silk Road have been found in Tang era tombs. The sculpting of these large figures shows keen observation, resulting in realistic statues. The Tang horses are among the most sought-after artworks in today's international art auctions; wealthy art patrons and museums try to have at least one Tang horse on display. It is amazing to consider that in Tang China, these glorious horses were viewed only once, on the funeral procession to the tomb.

A distinctive form of sculpture beginning in Tang times was the "tomb guardian." This creature was intended to be a fierce protector of the deceased and of the valuable grave goods that were interred along with the body. It was hoped that the tomb guardian would frighten away would-be grave robbers as well as evil spirits.

(One can see a certain resemblance between the tomb guardians and the roof guardians that were placed atop homes, also to frighten away evil spirits.) Sometimes tomb guardians were placed just inside the tomb, but often they were placed outside the tomb's outer door. Multiple guardians were typical; usually they had small variations among them but were still recognizable as to type. Generally they stood about three or four feet tall, approximately the size of the Tang tomb figures.

In later times, it became customary to deploy one or more larger-than-life stone grave guardians to protect a town's cemetery area, in addition to the smaller grave guardians that stood watch over individual tombs. A chimera (a mythological creature composed of elements of several different animals) was a typical selection. Chimeras in China usually combined the wings of a bird, the body and face of a lion, and the horns of a ram. The bird wings symbolized the spiritual world; the lion, power; and the ram, family loyalty, which continued after death.

The use of massive stone guardians reached its height at the Ming Tombs (1368–1644), built on a plain about 35 miles northeast of Beijing. The "Sacred Way"—the procession roadway to the 13 Ming emperors' mausoleums—is lined with 18 pairs of monumental human and animal figures. These stone sculptures, standing more than eight feet high, include four each of three types of officials (civil, military, and meritorious officials, who would help the emperor rule the empire), plus four each of six types of animals (lion, griffin, camel, elephant, unicorn, and horse). Pairs of animals and officials face each other across the roadway.

Buddhist Sculptures

Unlike Confucianism and Taoism, Buddhism was not native to China. But, like Christianity in Europe and Islam in the Middle East, Buddhism—which came from India—had an enormous effect

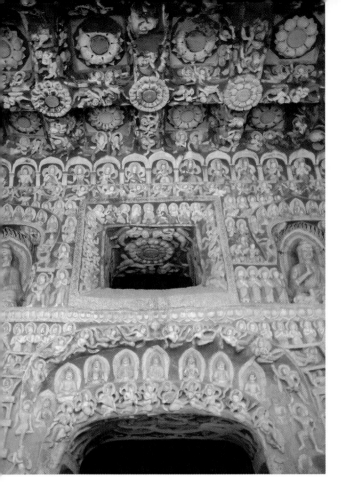

The arrival of Buddhism from India had a significant impact on Chinese sculpture. Shown here is a detail from one of the elaborately decorated Yungang caves, where more than 50,000 Buddha figures were carved into sandstone cliffs near Datong during the Northern Wei dynasty (A.D. 386–534).

on China's arts, especially its sculpture. If one browses through a museum with examples of Chinese sculpture arranged chronologically, the period of Buddhism's arrival is readily apparent. Suddenly the sculptures don't look Chinese anymore; instead they look as if they were fashioned in an entirely different country and imported into China. Huge monumental devotional statues of the Buddha himself were carved out of cliffs and erected in cave temples. These sculptures look very much like those carved in India. They are breathtaking and beautiful, but they look altogether different from the more realistic Chinese tomb sculptures.

Soon, however, the Chinese—who consistently proved capable of accepting different philosophies as part of the balance of life—adapted Buddhist traditions to a more Chinese aesthetic. The austerity of early Buddhist sculpture gave way to a more flowing style, as if the lines so beloved by painters and calligraphers were now being expressed in Buddhist sculpture as well.

As people incorporated the Buddhist saints into their daily lives, they adjusted and added them to the range of helpful gods and

goddesses they already prayed to. It became customary to purchase a small figurine representing a favorite god. Sometimes it was tucked into the sleeve as a good luck amulet; larger figurines were placed in the household's shrines. For example, the kitchen god statue was placed on or near the cooking stove. It was believed that once a year, the kitchen god reported to the principal gods on the behavior of the family—on who was good and who was bad. This was certainly a god whose favor was important to cultivate!

Another household god was Guan Yin, who in China evolved into the "Goddess of Mercy." Because women had few rights in traditional China, it was natural for Guan Yin to become the special protector of women. Although public temples contain primarily the Buddha and male bodhisattvas (Buddhist saints), in homes and personal shrines there is nearly always a small sculpture of the female Guan Yin. A particularly beautiful style of these Guan Yin figurines developed at the Dehua workshops during the Qing dynasty (1644–1911). These sculptures are pure white and are never painted—in fact, Europeans call this type of ware *Blanc de Chine* ("white from China"). These white sculptures are usually less than a foot high and, at their best, are supremely graceful works of art. They are not, strictly speaking, naturalistic; delicate

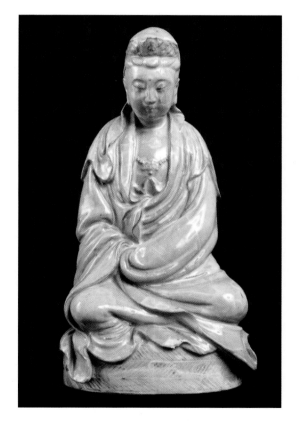

A porcelain Guan Yin figurine. In China, Guan Yin—originally a male bodhisattva—evolved into the "Goddess of Mercy," as well as the goddess prayed to for healthy children.

hands and fingers often seem too small, the head a bit too large, to be accurately realistic. But the forms and sculpting show beauty of line and invite meditation. In other words, these refined Buddhist sculptures have become very Chinese and are today recognized as small masterpieces of Chinese art.

A curious sculpture form that developed in China is the so-called Foo dog. In fact, a Foo dog does not represent a dog but a fantasy animal based on the lion. (The image in the background of certain pages in this book, beginning with the Introduction on page 6, is a Foo dog.) It is thought that the word *Foo* is a corruption of the word *Fo*, the Chinese name for Buddha. A pair of these sculptures was sometimes placed at the gates to Buddhist temples as early as the Han era (206 B.C.–A.D. 220). In the revival of Buddhism during Tang times (618–907), all Buddhist temples were protected by a pair of these stone lions. Eventually Foo dogs became popular at the entryways of homes, gardens, and places of business. Traditionally the Foo dogs were somewhat austere, unpainted stone sculptures meant to frighten away evil spirits. Gradually they became more colorful, doglike, and somewhat playful. In this version, usually of brightly glazed porcelain or stoneware, the male dog plays with a ball, symbolizing the earth, and the female cuddles a cub in her paws. European traders during the Qing dynasty, especially the English, loved these sculptures. The Chinese ceramics workshops obliged by making vast quantities of small, increasingly garish Foo dogs for export. Foo dogs remain popular today for homes and offices.

Garden Sculpture and Scholar Rocks

The Chinese scholar-artist longed to spend extended periods in the mountains, meditating on nature and creating great poems and paintings. But as the administrators of the emperor's government, these scholars often found it impossible to get away for long. As an alternative to an extended retreat, it became popular for the busy

scholar to create a "scholar garden," where he could spend a few hours at a time in contemplation. Although these gardens might be small—perhaps the size of a city backyard—they were designed to give the effect of nature's grandeur in the mountains.

Rocks, thought of as the "bones of the earth," were the principal element. There would be at least one tall, rugged-looking monolith, which symbolized the craggy northern mountains. The most treasured was a large, natural Lake Tai rock from Jiangsu Province. The surface of this stone would have deep holes and openings from the erosion caused by wind, water, and sand. Additionally, the scholar's garden might contain cave-like rocks, mounds of stones to simulate hills, interestingly colored pathways of smooth river pebbles to look like streambeds, and so forth. Water, wood, and architectural features were also used to give the feeling of a scholar's pavilion near water in the mountains. The Three Friends of Winter, or Winter Treasures—bamboo, pine, and plum—were planted along with the summer spiritual flower, pond lotus.

Although the garden rock was supposed to create a completely natural effect, sculptors often helped out nature by shaping the boulder to better suggest the mountains it represented. This was a demanding art, for as in diamond cutting, a wrong hammer blow could split and ruin the entire valuable boulder.

Scholars often brought a carving of their favorite rocks into their painting studios or personal studies. These scholar rocks were treasured for their colors and natural appearance. A subgenre of Chinese sculpture developed around these portable scholar rocks; they are still being carved and sold to tourists and home decorators today.

This young girl, a student at an arts and crafts school in Shanghai, is learning the delicate and difficult craft of silk embroidery. The Chinese have been working with silk for at least 5,000 years.

Crafts and Folk Art

Like people everywhere, the Chinese love to decorate their homes, their clothing, and other objects they use in everyday life. Certain folk arts and crafts are commonly associated with China, either because the Chinese invented them or because Chinese craftspeople attained an especially high level of skill and artistry.

Fabric Arts and Bottle Painting

Skill, dexterity, and patience are required to handle materials in very small spaces. Chinese artists and craftspeople have long demonstrated those qualities in such specialties as fabric arts and bottle painting.

The Chinese invented silk weaving at least 5,000 years ago. In the most refined fabrics, incredibly thin silk strands are woven single ply (not combined with other silk threads and twisted into thicker strands). Around A.D. 1500, these delicate but strong fabrics began to be stretched over large frames to make room dividers.

Although these screens could have been painted, in this craft, silk threads were dyed and then used for embroidery. The stitches are tiny, and colors are modulated in subtle shades. The impression a person gets upon entering a room with one of these embroidered silk screens is of looking at a large painting on silk. Only when the observer gets very close to the screen does he or she see that it is really silk needlework. Even more amazing, the embroidery is done in such a way that the front and back look the same, a perfect characteristic for a room divider that will be seen on both sides.

A related art, embroidery on brocade, was used to make the designs and office badges on imperial robes of state. As was the case with portraits of the Song and Ming emperors, clothes became increasingly luxurious as time went on. Chinese embroiderers became so proficient at creating artistic all-over designs on richly textured silk brocade—and used so many precious gold and silver embroidery threads in addition to the colored silks—that the embroidered robes were saved as valuable heirlooms when they went out of style. Some of these embroidered robes were sold during the economic distress at the end of the Qing dynasty and have made their way to museum displays in the West.

In a modern army, the position is ultimately more important than the individual who holds the position. A general has high status no matter who has the job of general. In order to quickly determine who has greater authority in the armed forces, rank badges (such as epaulets and chevrons) are displayed on the uniform. In the vast "army" of scholar-administrators in China, rank was also important. Because it was vital to quickly understand the rank and relative power of the various administrators who might visit a province or town, it became customary from around A.D. 1390 on for the imperial administrators to wear rank badges. These were large rectangular or circular embroidered patches, about eight inches wide, that were sewn onto the front

of the administrator's outer robe. Emblems were defined for the various ranks (dragon, crane, tortoise, and so on). If an old robe was discarded, the embroidered rank badges were removed and sewn onto the new robe. If an administrator died or was stripped of his duties, his rank badge was turned over to his replacement. These rank badges are quite rare today.

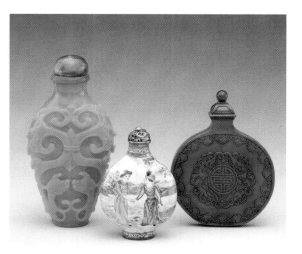

Tobacco arrived in China during the 17th century, and its popularity as snuff quickly spawned a new art form: the making of elaborately decorated snuff bottles. Of the three examples shown here, the one on the right is from the 1800s, the other two from the 1700s.

Tobacco, first cultivated in the Americas, made its way to China around the beginning of the Qing dynasty in the 1650s and quickly became popular among the wealthy classes as snuff. (Snuff is a finely powdered tobacco that is inhaled up the nostrils.) The expensive snuff was carried around in two- or three-inch-high bottles, and decorating these snuff bottles became a new art form. Some are carved from jade or quartz. An unusual type of snuff bottle—made of painted glass—required extraordinary skill. This is because the bottle was painted not on the outside, but on the inside. The painter poked the tiniest of brushes down the bottle opening and painted full-color scenes for the enjoyment and admiration of the snuff connoisseur. The earliest examples date from the 1880s, so this form was a relatively late development. Tourists still buy these fascinating items as souvenirs, although rarely are the bottles used for their original purpose of carrying snuff.

Carving and Cloisonné

Some of the most characteristic decorative arts in China involve carving. In the West, carving is often associated with whittling figures out of wood. In China, the materials carved were usually more luxurious. Jade carving, especially for the making of jewelry, began in ancient times and continued under the various Chinese dynasties.

One of the most distinctive types of Chinese carving is lacquer carving. Lacquer, which is made from the sap of trees belonging to the genus *Rhus*, was first used in China to protect and beautify wood. The preparation of the sap is a long and laborious process. Once the lacquer was prepared, an even more painstaking and time-consuming process was needed to coat the wood surface that was to be carved. Up to 30 coats of lacquer might be applied before a box was ready to go to the carver for decoration.

Ivory carving was another craft in which the Chinese excelled. Today ivory is no longer traded legally, to protect elephants from extinction. But many beautifully carved decorative items from China's past can be found in museums and private collections.

Several nations claim credit for inventing cloisonné. However, it is clear that the Chinese mastered the complex techniques of this metal art during the Ming dynasty and have continued creating admirable works ever since. Owing to its brilliant colors and crisp designs, Chinese cloisonné has been appreciated both in China and abroad. The making of cloisonné involves elaborate and complicated processes: base-hammering, soldering, enamel filling, enamel firing, polishing, and gilding. Workshops producing cloisonné jewelry and other small objects still abound in contemporary China.

Furniture

The making of fine wood furniture is one of the highlights of the Chinese decorative crafts. The surviving examples are predominantly of the Ming and Qing eras. The Ming era furniture was designed with

The Chinese, it is believed, invented kites no later than 500 B.C. Kite making and flying remain popular pastimes in contemporary China. This scene is from Tiananmen Square in Beijing.

refined, minimal lines that emphasized the beautiful dark colors of the specialty woods used. In Qing times, the shapes were embellished with marquetry, lacquer surfaces, and extensive filigree carving.

Folk Art

The finer crafts were beyond the means of all but the well-to-do in Chinese society. But workers and peasants enjoyed arts they could create themselves.

One of the favorite folk arts is kite making. Many traditional shapes, including butterflies, dragons, falcons, and dragonflies, have evolved. Bright paper or silk shapes are stretched onto narrow split bamboo strengtheners to create Chinese kites.

Paper cutting is another of the popular folk arts. An ancient craft, it is said to have begun around A.D. 400, during the turbulent times between the Han and Tang dynasties. Paper cutting for window decoration was most popular, so the craft is often described as "making window grilles." Often designs were also used as patterns for everyday embroidery. The color of the paper was traditionally red (the color of wealth and good fortune), though other bright colors are used today.

The bustling city of Shanghai, with its multitude of new, cutting-edge skyscrapers, is a showcase of modern commercial architecture.

10

Art and Architecture in China Today

In modern times, China has undergone a series of major social upheavals. It has also been, to an extent rare in its long history, susceptible to influences from non-Chinese cultures. When similar circumstances prevailed in the past, China saw not simply changes in, but a genuine flowering of, its arts and architecture. And this is precisely what is happening today.

Background

As previously discussed, Chinese culture developed largely in isolation and was therefore unique. Traditional Chinese art and architecture differ from those found elsewhere. Yet during the few times when China was influenced by other cultures, the effect on Chinese art was profound. When Buddhism came to China from India, sculpture changed dramatically and a new temple form, the pagoda, was developed. When the Chinese actively traded along the Silk Road to the

Middle East, the blue-and-white Persian designs revolutionized Chinese ceramics. When the European Jesuits helped administer China's last empire, elements of Western realistic painting and the preference for full-palette color crept into Chinese paintings and porcelain decoration.

In the 20th century, several Western cultures dramatically influenced Chinese art and architecture. Right after the fall of the Qing dynasty in 1911, wealthy Chinese parents began sending their children to European and American universities. Chinese art students were immensely influenced by the art scene in Paris during the 1920s, and they learned to paint the oil paintings then in vogue. In fact, a Parisian-style art academy was established in Shanghai, where for almost 20 years, French painters taught eager Chinese students the new techniques.

After the Communists under Mao Zedong defeated the Nationalists and proclaimed the People's Republic of China in 1949, the new Chinese regime turned to its more established Communist neighbor, the Soviet Union, for aid and direction in a variety of areas. In the early years of the People's Republic, Soviet influences on Chinese architecture and art were dramatic. Boxy apartment and office high-rises replaced the traditional Chinese architecture of mortise and tenon wood joinery and flaring tile roofs. New government buildings showed a similar massive severity.

In painting, the official Soviet style, called "socialist realism," came into vogue. Under socialist realism, artists were supposed to portray Communist themes such as class struggle and the triumph of the proletariat in a realistic manner; in practice, however, the art produced wasn't realistic, but merely exalted the Communist state and its leaders. Chinese artists fulfilled the requirements of socialist realism by painting a multitude of scenes featuring smiling Chinese workers and peasants building the new China.

After Mao's death in 1976, China gradually opened to travel and

A young girl contemplates some thoroughly modern portraits in a Beijing gallery, 2003. Such paintings would have been unimaginable in Mao's China, when artists churned out works glorifying the state, its leaders, and communism in the so-called socialist realism style.

trade with the non-Communist world. During the last quarter century, the United States and other Western industrialized nations have had a major influence on Chinese culture. Architects from France and the United States have helped to transform the city of Shanghai into a glittering showcase of some of the most innovative and "edgy" commercial architecture anywhere. Chinese artists and sculptors have been influenced by the movement in American art known as "social realism," by which artists during the Great Depression sought to depict social problems and the difficulties of everyday life for common people; in their style of social realism, contemporary Chinese artists comment upon the changes, both good and bad, that are occurring in China today. All these Western influences are being absorbed into today's Chinese aesthetic sense.

In addition, as previous chapters have discussed, during periods

of political disruption and war, many of the arts in China became more profoundly sensitive. This trend can be seen, for example, in the poetry of the Warring States period or in paintings by the recluse scholar-artists who lived amid the turmoil after the fall of the Song dynasty and the conquest by the Mongols. China in the 20th century suffered social disruption on a large scale: the fall of the Qing dynasty in 1911, Japanese military occupation between 1937 and 1945, civil war between the Communists and the Nationalists, disastrous economic and social policies under the rule of Mao Zedong.

Chinese people observe that the last emperors in a dynasty are so corrupt or weak that the heavens send disasters to the nation as a sign that a new dynasty is needed. In the 19th century, the last rulers in the Qing dynasty allowed China to fall far behind the West in technology and military preparedness. Because of this, China lost wars with the English and Japanese and was forced to give up land to foreign merchants. Chinese people were deeply and personally humiliated by this situation.

The first emperor or founder of a new dynasty traditionally gains power through force and often destruction. Today some Chinese regard Mao as, in effect, the founder of a new "dynasty." At the head of a peasant army, he defeated the forces of the corrupt Nationalist government and created the People's Republic of China. But, like founding emperors from China's past, Mao also destroyed. Perhaps most notoriously, he unleashed the decade-long Cultural Revolution, during which anyone in a position of authority or anyone deemed an intellectual was vulnerable to being terrorized and humiliated by marauding bands of young Communist militants known as the Red Guards. Children denounced their parents, students their teachers, and workers their supervisors. Chinese society reeled as hundreds of thousands of educated people branded "closet capitalists" were sent to "reeducation" camps and forced to perform menial jobs or hard labor to

correct the "errors" in their thinking.

Chinese people understand that it is the responsibility of the emperors who come after the founding emperor to restore tranquility and make the country productive again. After Mao's death in 1976, which effectively ended the Cultural Revolution, Deng Xiaoping steered China toward economic and cultural recovery. Succeeding leaders have sought to energize the people to make better lives.

Now permitted a much greater degree of artistic freedom than was tolerated under Mao, Chinese writers, filmmakers, and fine artists have begun expressing the poignant horror wrought by the 20th century's tragic disruptions to Chinese life. Some painters are rediscovering traditional techniques and formulas. Others are using Western methods and materials to examine current issues. There is a vitality, newness, and excitement about the arts and architecture being created throughout China today.

Art in China Today

After the fall of the Qing dynasty and the subsequent formation of a Chinese republic, the visual arts found a special place in Chinese society that has continued ever since. Painting academies, as Robert L. Thorp and Richard E. Vinograd point out, became the main theaters where political programs and art-world politics played out. Since many Chinese during the republic period were educated in Europe and the United States, they had an appreciation for Western realism. Most traditional Chinese painting consisted of subtle, personal reflections on visual symbols and poetic allusions. Western-style realistic art could tell entire stories, with more clarity than could old Chinese-style paintings. This was particularly important in the early 20th century because literacy did not become widespread until well into the 1950s.

During the most restrictive days of the People's Republic of China, propaganda art was plentiful and powerful. As in past periods of

turmoil and political wars, an artist would have put family and self in jeopardy by straying from the official doctrine. Under Deng Xiaoping, however, the socialist ideal of self-sacrifice, as well as the drab uniformity that prevailed under Mao, was replaced by an emphasis on entrepreneurship and consumerism. With the growing economic freedom came increased artistic freedom—Chinese artists found that they could now criticize and satirize Chinese society and, to a certain extent, government policies and officials. This is precisely what much of the current Western-influenced Chinese art does.

Other artists have been influenced by American social realism. Like the Chinese protest poets of old, they hope to spur reforms. Some sculptors, for example, have created life-size groups of plaster models that look like the rural underclass who collect on urban streets hoping to be hired, even though they don't possess the correct documents; many of these migrants are exploited by unscrupulous employers. Other artists show the effect of wealth, consumerism, and the emotional ennui of an existence without values that is beginning to afflict the business magnates in the thriving "capitalist zones" like Shanghai.

Despite the influence of Western realism, the Chinese never really stopped believing in traditional Chinese art methods. Rather, an equally important, parallel movement among Chinese artists arose to revitalize traditional painting techniques and subjects. Late Qing art had become trite, manneristic, and incapable of reflecting the momentous events and issues occurring in modern China. As in previous times, artists went back in history and studied the great masters. This rediscovery was considered so important that the new painting academies established after the fall of the Qing dynasty typically had one set of classrooms and teachers experimenting with traditional Chinese materials and theories, and another set of classrooms and teachers exploring Western realism. To this day, China's art schools still teach parallel courses in Chinese and

Western art. Both concentrations are given equal status and funding, and it is considered a great accomplishment to master both the Chinese and Western traditions.

Although modern Chinese art has been influenced by Western styles, it cannot be said that all major developments in Western art have had an impact. Abstractionism, a powerful movement in European and American art during most of the 20th century, didn't catch on to any significant extent in China. In the few cases in which a Chinese piece seems to verge on the abstract, closer analysis usually reveals its firm grounding in Chinese visual traditions.

Architecture in China Today

Opposite the former Imperial Forbidden City on Tiananmen Square is the new center of government, the Great Hall of the People. Built in 1959, it is an impressive structure. In its total floor space of more than 1.8 million square feet, it contains 300 meeting halls, waiting rooms, and offices. The main hall, where the National People's Congress meets, has a seating capacity of just over 10,000. Each of the smaller meeting halls is named after a province, a municipality, or an autonomous region and is furnished in the local style of its namesake. For all this symbolism and reference to Chinese places, the building, though certainly imposing, looks as if it could have been built in any Western capital.

Near the Great Hall of the People, at the center of Tiananmen Square, stands another imposing structure: the mausoleum of Mao Zedong, who died in 1976 at the age of 82. Inside the mausoleum are the preserved remains of Mao, permanently on display in an open coffin in a refrigerated glass chamber. Although the public Soviet-style sculpture in front of the building looks anything but Chinese, the building itself contains subtle elements of traditional Chinese architecture. Pillars support a heavy overhanging up-flared roof structure. Like the imperial palaces with their ramps and tamped-earth

Above: The National People's Congress in session at the Great Hall of the People in Beijing. The main hall of the complex, completed in 1959, seats 10,000. Opposite page: The legacy of Mao and communism remains strong, even amid today's post-Mao era of economic reform, as this building in Tiananmen Square suggests.

platforms, Mao's mausoleum is raised on a platform and is reached by a wide ramp of stairs.

By the early 1990s, China was well on its way toward creating a new economic vitality. The central government decided at that time to make several "special economic zones." In these zones, capitalism would be encouraged. Foreign businesses would be invited to build branch offices, bring expertise, and invest capital. The most splendid of these economic zones is Shanghai. Formerly a sophisticated cosmopolitan city, but nearly demolished during the 20th century's wars and turmoil, Shanghai needed to be built from the ground up. Foreign architects were invited to design the most modern buildings imaginable, buildings that would attract the attention of the world. Shanghai's glittery new office buildings did just that: they have been excellent advertising for the startling, brand-new city.

But perhaps the most moving and significant story in contemporary Chinese architecture is the new Bank of China building in Beijing. Just as it has sought closer relations with the non-Communist

Western nations, China seems on a path of reconciliation with the expatriate community.

The Pei family had been influential in southern China, but many of its members relocated to the United States in the 1920s and 1930s. There several Pei brothers formed the architectural firm Pei Associates. The lead architect, I. M. Pei, soon distinguished himself as an extraordinary talent, and today he is recognized as one of the most brilliant living architects. Among his designs are the glass "pyramid" outside the Louvre in Paris, and the landmark glass and

I. M. Pei's ultramodern design for the Bank of China office tower in Hong Kong helped the Chinese-American architect's firm win an invitation from the People's Republic of China to design a new Bank of China headquarters in Beijing.

metal-banded Bank of China Tower in Hong Kong.

In a lecture given in 2001 at the China Institute in New York City, Pei said that the invitation for his firm to design the Bank of China building in Beijing was significant. It was, he noted, a clear message to Chinese everywhere that families who had fled were welcome back, to share in the culture and vitality of the new China. Grateful for the honor, Pei and his associates designed a modern glass structure with interior spaces that might best be described as updated versions of traditional Chinese homes—courtyards with bamboo plantings, round moon gates, and so on. Recalling his experiences on the project (the building opened in May 2001), Pei noted the importance of the transfer of knowledge to the Chinese workers and craftspeople that had occurred during construction. They learned masonry, glass, and welding skills that they could use on other building projects throughout China. They also learned safety rules, as well as structural and materials engineering. Many of the buildings built in the Soviet-influenced era of the 1950s and 1960s were already in need of serious repair. Pei felt that the sometimes inadvertently haphazard engineering and shoddy materials would be a thing of the past in 21st-century China. It was an encouraging and hopeful report on the new state of architecture in China today.

China's leaders have recently decided to promote tourism as part of their strategic economic goals. Because much of the country's lure as a tourist destination is tied up in its extraordinary cultural history, a massive effort is under way to preserve, restore, and reconstruct traditional works of Chinese art and architecture— many of which were neglected or damaged during the rule of Mao. China is especially proud to be hosting the Olympics in 2008. Artists, architects, and restorers are among the Chinese who are busy preparing the country for this exciting event, when, it is hoped, the eyes of the world will see the vibrant new face of this ancient culture.

Chronology

ca. 5000–ca. 2000 B.C. Neolithic period in China. Artistic developments include: painted pottery; "Chinese" art motifs such as dragon and tiger made from shells in grave; jade protectors; black eggshell-thin pottery; crude bronze objects. Architectural developments include: tamped-earth walls and platforms; early mortise and tenon joinery.

ca. 2000 B.C. Bronze Age begins.

ca. 1700–1027 B.C. Shang dynasty. Important cultural and artistic developments: bronze ritual vessels reach height of artistry; taotie mask is major decorative motif; experiments in porcelain making; oracle bone writing.

ca. 1027–771 B.C. Western Zhou dynasty. Bronze bells reach height of artistry.

6th century B.C. Lao-tzu believed to have founded Taoism, which emphasized reverence for nature.

ca. 551 B.C. Birth of Confucius. Over the course of his life, Confucius will articulate his highly influential rules of good behavior; promote family loyalty; annotate the ancient mystical book *I Ching* and collect 305 poems, establishing the art of poetry as a worthy pastime.

221–207 B.C. Qin dynasty marks the first time China has been unified under a single ruler. Artistic and cultural developments include: establishment of official "seal script"; burning of most books that had been created before Qin; construction of much of the Great Wall; sculpting of life-size terra cotta army, which was buried with the emperor.

206 B.C.–A.D. 220 Han dynasty. Artistic, architectural, and cultural developments: walled towns and courtyard family house compounds; establishment of system of state administration by scholars; pottery grave figures; invention of paper (ca. 100 B.C.); clerical brush calligraphy, which later evolved into "classical" calligraphy, made the standard writing.

3rd–7th century Following the fall of the Han dynasty, Buddhism spreads in China. Monumental sculptures and cave temples in Indian style are built. Style influences Chinese religious architecture to come.

618–907 Tang dynasty. Major artistic and cultural developments: block printing of books; golden age of poetry; Buddhism established alongside Confucianism and Taoism; many wall frescoes showing cosmopolitan court are painted; active trade along the Silk Road to Middle East; *sancai* drip glazes on ceramics; porcelain process perfected.

960–1279 Song dynasty (Northern Song: 960–1127; Southern Song: 1127–1279). Artistic and cultural developments: monumental landscape painting; "birds and flowers" painting, emphasizing delicate realism; minimalist Chan painting, emphasizing bold brushwork; height of porcelain art in China; building modules, sizes standardized; pagoda Buddhist temple style evolves.

1279–1368 Yuan dynasty. First Chinese experiments with blue-and-white porcelain to compete with Persian blue-and-white mosque tile industry. Venetian traveler Marco Polo visits Mongol Yuan court and later gives account of his adventures.

1368–1644 Ming dynasty. Artistic and cultural developments include: blue-and-white porcelain reaches its height; attempt to return to "pure" Han Chinese artistic aesthetic; literati circles of scholar-painters vie with one another for

social prominence and "correct" painting formula; Ming Tombs with massive stone grave guardians built outside of Beijing; cloisonné perfected.

1644–1911 Qing dynasty. Artistic and cultural developments: Blanc de Chine white figurines of personal gods and goddesses reach artistic height; much export ware porcelain produced for trade with Europe especially; painting porcelain after firing enables fashionable full-color palette painting; Manchu Qings invite Europeans into their empire, bringing Western artistic influences; a scholar discovers oracle bone writing on "dragon bones" he was about to grind for medicine in 1899.

1912 Following the fall of China's last imperial dynasty, the Republic of China is established. Over the following years, many children of wealthy Chinese are educated in the West and bring back to China the techniques of Western realistic painting.

1937–1945 Japanese occupy large portions of China.

1949 The People's Republic of China (PRC) is established, with Mao Zedong as its leader; the Beijing dialect "Putonghua" is later made the national spoken language in the PRC, while simplified script is made the written language standard.

1959 The Great Hall of the People in Beijing, where the People's Congress meets, is completed.

1966 Mao launches the Cultural Revolution. Over the next decade, social chaos reigns as Communist Party officials, teachers, intellectuals, and other members of the "elite classes" are denounced for ideological offenses, removed from their posts, and sent to work camps in the countryside to be "reeducated"; much traditional art and architecture is destroyed by the marauding "Red Guards."

1976 Mao dies, and the Cultural Revolution soon comes to an end.

1978 Deng Xiaoping comes to power; as China's leader during the 1980s he promotes economic reform. Gradually a somewhat greater degree of individual freedom is tolerated, and non-Communist art movements, especially social realism, become influential.

1990 Shanghai is selected to be a new "capitalist" economic zone, signaling the beginning of a building boom that transforms the city into a showcase of cutting-edge commercial architecture.

2001 The new Bank of China headquarters in Beijing opens; the building was designed by the firm of I. M. Pei, the world-renowned Chinese expatriate architect.

2003 Dancing "jing" character, based on traditional calligraphy, wins 2008 Beijing Olympics logo competition.

2008 Olympics to be held in Beijing.

Glossary

Blanc de Chine—an unpainted white porcelain, made from the white clay near Dehua and usually fashioned into small figurines or tea implements.

blue and white—a cobalt blue glaze decoration scheme on white porcelain.

bronze—a metal made in a complex process from copper, tin, and usually zinc.

calligraphy—in China, the brushing of word characters in ink.

ceramic—a hard fired clay object that is stronger than pottery.

cloisonné—a decorative process in which metal filaments are fused to the surface of an object to outline a design that is filled in with enamel colors.

dynasty—a group of rulers that maintains power for several generations, with succession typically determined by blood relationship.

export ware—ceramics and porcelains designed and decorated specifically for export to foreign markets.

lacquer—a dark substance obtained from certain trees and used as a natural varnish.

mortise and tenon—a joint made by grinding a hole in one pole and inserting the pointed end of a second pole into it.

Neolithic—relating to the latest period of the Stone Age.

paleontologist—a scientist specializing in the study of life during past geologic periods through fossil remains.

pictogram—a stylized picture representing a word or idea.

porcelain—an extremely hard white translucent ceramic, invented in China.

pottery—objects made from hardened clay.

sancai—a distinctive, three-colored Tang glaze (usually green, amber, and cream colored).

Silk Road—the name given to the ancient set of trade routes linking China and the Middle East and Europe.

tamped earth—a building process in which layers of earth are pounded hard to build strong, thick walls.

taotie—a characteristic "monster mask" found on nearly all ancient Chinese bronze ritual vessels.

terra cotta—a soft, reddish tan pottery.

Three Perfections—calligraphy, poetry, and painting, considered the most important artistic forms in China.

Further Reading

Barnhart, Richard M., et al. *Three Thousand Years of Chinese Painting*. New Haven, Conn., and Beijing: Yale University and Foreign Language Press, 1997.

Blunden, Carolyn, and Mark Elvin. *Cultural Atlas of China*, rev. ed. New York: Checkmark/Facts on File, 1998.

Debaine-Francfort, Corinne. *The Search for Ancient China*. New York: Abrams, 1999.

Eberhard, Wolfram. *A Dictionary of Chinese Symbols: Hidden Symbols in Chinese Life and Art*. London and New York: Routledge, 1986.

Fong, Wen C. *Between Two Cultures: Late-Nineteenth and Twentieth Century Chinese Paintings from the Robert H. Ellsworth Collection in the Metropolitan Museum of Art*. New York, New Haven, and London: The Metropolitan Museum of Art, 2001.

McNaughton, William, and Li Ying. *Reading and Writing Chinese*, rev. ed. Boston and Tokyo: Tuttle Publishing, 1999.

Paludan, Ann. *Chronicle of the Chinese Emperors. The Reign-by-Reign Record of the Rulers of Imperial China*. London: Thames & Hudson, Ltd., 1998.

Steinhardt, Nancy S., ed. *Chinese Architecture*. New Haven, Conn.: Yale University and New World Press, 2002.

Sze, Mai-mai, ed. and trans. *The Mustard Seed Garden Manual of Painting*. Princeton, N.J.: Princeton University Press, 1977.

Thorp, Robert L., and Richard Ellis Vinograd. *Chinese Art & Culture*. New York: Harry N. Abrams Inc., 2001.

Wilkinson, Kenneth. *Chinese Language, Life & Culture*. London: Hodder & Stoughton, Ltd., 2002.

Internet Resources

http://www.chinapage.com/museum.html

Links to museums around the world with collections of Chinese art.

http://www.china-avantgarde.com

Virtual gallery of modern art in China today.

http://www.albany.edu/faculty/hartman/eac280

Excellent chronological summary with representative pictures.

http://www.orientalarchitecture.com/

Contains pictures and information on architecture throughout China (as well as other Asian nations).

http://www.pdfmuseum.org.uk/

View this preeminent collection of Chinese porcelains online.

http://www.asiasociety.org/arts/index.html

Lectures and gallery exhibitions on Asian art.

Index

Numbers in **bold italics** refer to captions.

Picture Credits

Page

12: IMS Communications, Ltd.
14: Bettmann/Corbis
16: Hulton Archive/Getty Images
17: Hulton Archive/Getty Images
20: STR/AFP/Getty Images
24: Asian Art & Archaeology, Inc./Corbis
27: Erich Lessing/Art Resource, NY
28: Liu Jin/AFP/Getty Images
30: Corbis Images
32: Jason Schmidt/Getty Images
35: Charles & Josette Lenars/Corbis
40: Iko Lee/Getty Images
42: Ricky Wong/Sinopix
44: Christie's Images/Corbis
48: Burstein Collection/Corbis
53: Giraudon/Art Resouce, NY
57: Snark/Art Resource, NY
60: Lowell Georgia/Corbis
62: IMS Communications, Ltd.
67: Christie's Images/Corbis
68: Brandon A. Hollihan
69: Brandon A. Hollihan

70: IMS Communications, Ltd.
73: Corbis Images
75: IMS Communications, Ltd.
77: Corbis Images
79: Corbis Images
80: Forrest Anderson/Time Life
 Pictures/Getty Images
84: Werner Forman/Art Resource, NY
85: Araldo de Luca/Corbis
88: Carl Mydans/Time Life
 Pictures/Getty Images
91: Royal Ontario Museum/Corbis
93: Colin Galloway/Sinopix
94: Liu Jin/AFP/Getty Images
97: STR/AFP/Getty Images
102: Ma Li/Sinopix
103: IMS Communications, Ltd.
104: IMS Communications, Ltd.

Contributors

SHEILA HOLLIHAN-ELLIOT is a popular writer on the arts. Fascinated with Chinese art and culture since she was a child and her father did business in the "Red China" of the 1950s, she has spent time studying firsthand the history, the arts, and the enormous changes taking place in China today. She has examined public and private Chinese art and antiquities collections throughout the world. She graduated from Vassar College and is a member of The China Institute in New York City. She is also the author of *Ancient History of China*, in this series.

JIANWEI WANG, a native of Shanghai, received his B.A. and M.A. in international politics from Fudan University in Shanghai and his Ph.D. in political science from the University of Michigan. He is now the Eugene Katz Letter and Science Distinguished Professor and chair of the Department of Political Science at the University of Wisconsin–Stevens Point. He is also a guest professor at Fudan University in Shanghai and Zhongshan University in Guangzhou.

Professor Wang's teaching and research interests focus on Chinese foreign policy, Sino-American relations, Sino-Japanese relations, East Asia security affairs, UN peacekeeping operations, and American foreign policy. He has published extensively in these areas. His most recent publications include *Power of the Moment: America and the World After 9/11* (Xinhua Press, 2002), which he coauthored, and *Limited Adversaries: Post-Cold War Sino-American Mutual Images* (Oxford University Press, 2000).

Wang is the recipient of numerous awards and fellowships, including grants from the MacArthur Foundation, Social Science Research Council, and Ford Foundation. He has also been a frequent commentator on U.S.-China relations, the Taiwan issue, and Chinese politics for major news outlets.